Matisse in The Cone Collection

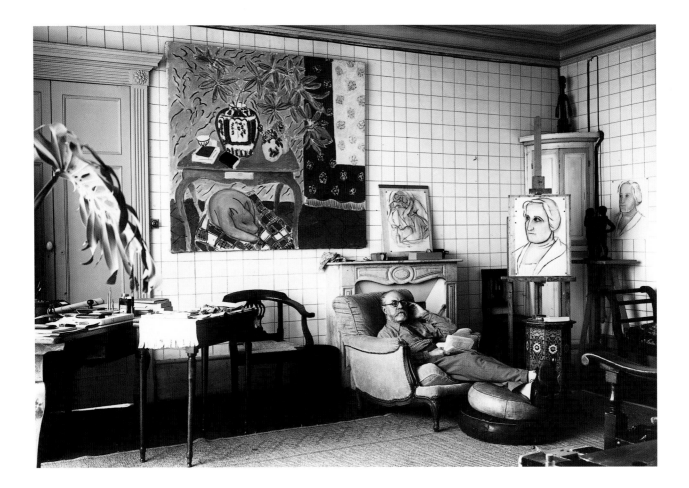

Henri Matisse in studio with
Interior with Dog and portraits
of Etta Cone, around 1934.
Photo Archives Matisse–D.R.

Matisse in The Cone Collection
The Poetics of Vision

Jack Flam

The Baltimore Museum of Art

Published on the occasion of the reopening
of The Cone Collection, April 22, 2001

Dedicated to Edward T. Cone, nephew of Claribel and Etta Cone. His memory of their passion for modern art inspires the Museum's commitment to the study and presentation of this remarkable collection.

Library of Congress Cataloging-in-Publication Data

Flam, Jack D.
Matisse in The Cone Collection: The Poetics of Vision/Jack Flam
p. cm.
ISBN 0-912298-73-1 (paper)
1. Matisse, Henri, 1869–1954—Criticism and interpretation.
2. Cone, Claribel—Art collections.
3. Cone, Etta—Art collections.
4. Art—Private collections—Maryland—Baltimore.
5. Baltimore Museum of Art.
I. Matisse, Henri, 1869–1954.
II. Baltimore Museum of Art.
III. Title.

ND553.M37 F449 2013
709'.2—dc21 00-069782

Printed in China

Contents

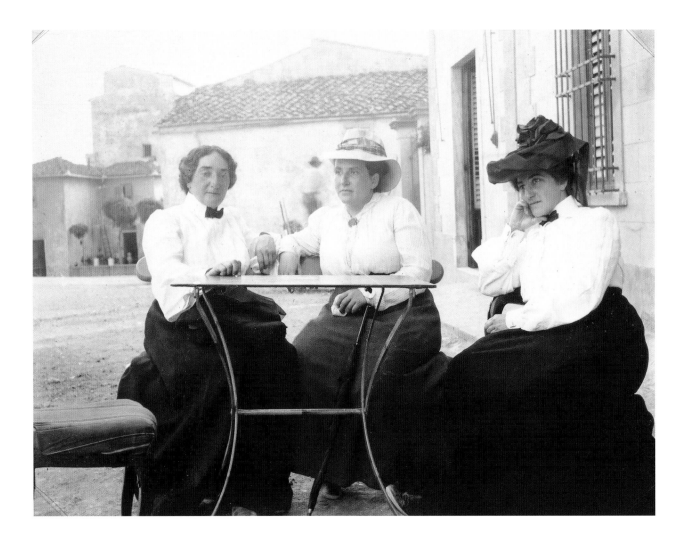

Claribel Cone, Gertrude Stein,
and Etta Cone, June 26, 1903,
Settignano/Fiesole. The Baltimore
Museum of Art, Cone Archives

Foreword

In 1950 The Baltimore Museum of Art was the recipient of an exceptional gift — over three thousand works of art collected by two remarkable Baltimoreans, the sisters Claribel and Etta Cone. Formed over a fifty-year period, The Cone Collection is one of the most important holdings of modern art in the world, and it is by far the most significant collection presented to this Museum. Its preeminence is established by over five hundred paintings, sculpture, prints, drawings, and illustrated books by Henri Matisse and major works by Picasso, Cézanne, van Gogh, Gauguin, and other masters of late nineteenth- and early twentieth-century French art. The collection eventually included several important paintings and drawings from the sisters' beloved brother, Frederic. Etta Cone, surviving her sister by two decades, decided that the Museum, and Baltimore, demonstrated a sufficient commitment to modern art to satisfy the suggestion in Claribel's will that the Museum receive the collection, provided "the spirit of appreciation for modern art in Baltimore became improved."

Certainly, Claribel and Etta knew Baltimore well. They were born and raised here, two daughters among thirteen children of affluent Jewish parents whose wealth was earned in the grocery and textile industries. Although the sisters traveled widely, the city remained their home. Claribel (1864–1929), the elder sister, was a respected doctor and pathologist, who had a brief tenure at the turn of the century as the president of the Women's Medical College in Baltimore. Etta (1870–1949), a dedicated amateur musician, managed the household for her family. With a generous annual income from inheritance and the successful Cone businesses, Claribel and Etta were financially secure, permitting them to travel abroad and pursue their interests.

In the late 1890s they became close friends with Gertrude Stein, who was attending medical school in Baltimore at The Johns Hopkins University. The Stein family, including Gertrude, brothers Leo and Michael, and sister-in-law Sarah, became central to the Cones' artistic education, encouraging them to learn more about art and aesthetics, so much so that Etta later credited Leo Stein with developing her eye for modern art. Later, in Paris, the Steins introduced Etta to Pablo Picasso in 1905 and Henri Matisse in 1906, thus beginning the Cones' forty-year odyssey of collecting works directly from contemporary artists. Again and again, the Cone sisters demonstrated wisdom and insight in acquiring works of unusual quality by modern artists at a time when many of them were not yet widely known or appreciated.

Unlike many of the more episodic collectors who supported Matisse—the Russians Sergei Shchukin and Ivan Morozov, or the American Albert Barnes—the Cone sisters sustained

their commitment to the artist for over forty years, first together, and then Etta on her own after Claribel's death in 1929. They saw most of his major exhibitions at the Galerie Bernheim-Jeune in the 1920s and bought significant works by him. Although Claribel bought relatively few paintings and sculptures before her early death, she purchased some highlights of the collection, including Matisse's *Blue Nude* and masterpieces by his predecessors, such as Cézanne's *Mont Sainte-Victoire Seen from the Bibémus Quarry*. In the next two decades Etta bought directly from artists and purchased both early and contemporary paintings by Matisse, as well as art by his contemporaries, that are masterpieces of the collection.

After her sister's death, Etta turned to Matisse as a partner in forming her collection of his art. Well aware that Etta planned to give the family's collection to an American museum, he wanted to be represented by his best works of art. Almost as soon as they were painted, Etta acquired many of the definitive examples of his artistic exploration from the 1930s, including *The Yellow Dress, Interior with Dog, Large Reclining Nude* (also known as the *The Pink Nude*), and *Purple Robe and Anemones*.

Because she was fascinated by the artistic creative process, Etta had a particular interest in acquiring works in a variety of media—sculpture, drawings, and prints. In 1933 she purchased the entire ensemble of drawings, prints, and copperplates for Matisse's illustrated book, *Poésies de Stéphane Mallarmé*. Three years later, she purchased *The Pink Nude*, a work that Matisse had introduced to her in their correspondence with a series of twenty-two photographs documenting

his creative process from start to finish. A serious and systematic collector, Etta also wanted to provide a historical context in the collection for her favorite artist and spent her later years collecting works by Matisse's nineteenth-century predecessors, such as Eugène Delacroix, Jean-Auguste-Dominque Ingres, Jean-Baptiste-Camille Corot, Edgar Degas, Paul Cézanne, Henri de Toulouse-Lautrec, Vincent van Gogh, and Paul Gauguin.

This reinstallation, the first comprehensive renovation of the Cone Wing since it opened in 1957, has been an enormous undertaking, involving a dedicated team of professionals within the Museum and beyond. We extend our deepest gratitude to Trustee Richard Donkervoet for oversight of the architectural changes made to the galleries and to the consulting designers—David Harvey, Vice-President for Exhibitions at the American Museum of Natural History, New York, for his sensitive redesign of the gallery spaces; and Gordon Anson, Chief Lighting Designer for the National Gallery of Art, Washington, D.C., and Brian O'Connell for design of the new lighting system.

Our sincere thanks to the Museum staff who worked energetically on all aspects of the project: Kathleen Basham, formerly Associate Director; Karen Nielsen, Director of Exhibition Design & Installation; Alan Dirican, Deputy Director for Operations & Capital Planning; Jay Fisher, Deputy Director for Curatorial Affairs and Senior Curator of Prints, Drawings & Photographs; Katy Rothkopf, Curator of Painting & Sculpture; Allison Perkins, Deputy Director for Education & Interpretation; Becca Seitz, Deputy Director for Marketing & Communications; Anne Mannix, Director of Public

Relations; Michelle Boardman, Manager of Creative Services; Judith Gibbs, Deputy Director for Development; and Margaret Blagg, formerly Manager of Government & Foundation Relations.

We wish to thank Jack Flam for his thought-provoking and perceptive essay; Fronia W. Simpson for her thoughtful editing; J. Abbott Miller and Jeremy Hoffman of Pentagram Design Inc., for a beautiful catalogue design; and Georges Matisse and Wanda de Guébriant, from the Matisse family archives in Paris.

A project of this magnitude would be impossible without the financial support of generous donors. We are particularly grateful to Edward T. Cone, whose unprecedented support has enabled the Museum to create such beautiful new galleries. Additional major gifts were made by the City of Baltimore, the Middendorf Foundation, Inc., Jeanette and Stanley Kimmel, and The William G. Baker, Jr. Memorial Fund. The inaugural exhibition was sponsored by Deutsche Bank and Deutsche Banc Alex. Brown. We also extend our thanks to the Cone family for their interest and enthusiasm in this special project.

Doreen Bolger
Director

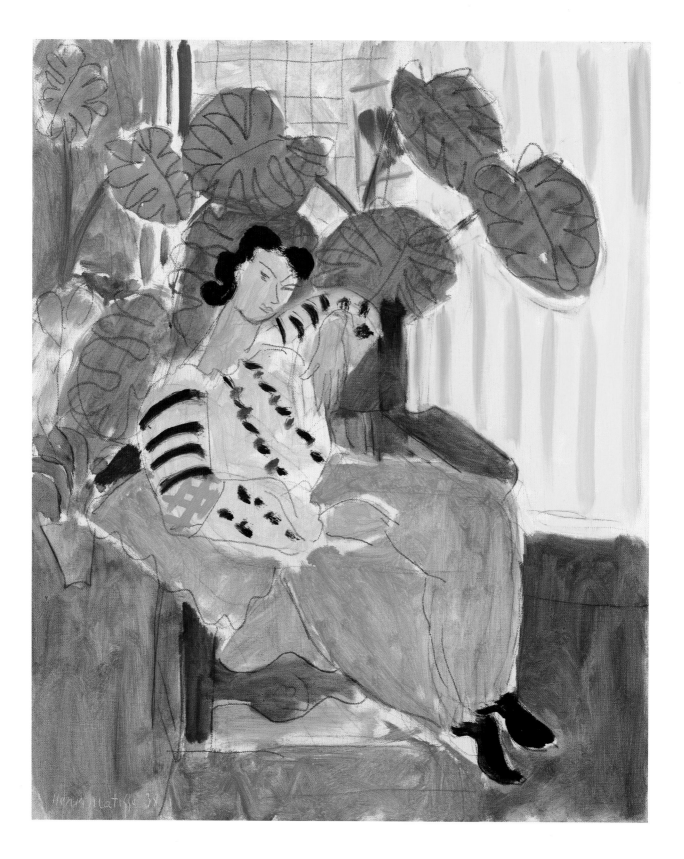

Looking at Matisse

1 Brenda Richardson, "Dr. Claribel and Miss Etta," in Brenda Richardson, *Dr. Claribel & Miss Etta: The Cone Collection of The Baltimore Museum of Art* (Baltimore Museum of Art, 1985), p. 58.

The Cone Collection, formed over the course of half a century by Claribel and Etta Cone and bequeathed to The Baltimore Museum of Art in 1950, contains one of the world's most important gatherings of works by Henri Matisse. It also reflects a very particular view of the artist's work. Unlike other major Matisse collections, most of the paintings in The Cone Collection were done after World War I, when Matisse gave particular attention to mixing formal rigor with decorative charm and alluring subjects. This emphasis on the more sensual aspect of Matisse's work may result from the Cone sisters' preference for paintings that had familiar subject matter as well as solid formal values. Etta, in particular, felt that the tenets of formalism, which she learned early in the century from Gertrude Stein's brother Leo, could be embraced "without sacrificing the familiar comforts of subject matter."[1] Matisse, for whom form and subject were inextricably linked, combined them

in a more balanced way than any other major twentieth-century artist.

As a result, Matisse's art is both very accessible and surprisingly complex. More than with most artists, what one gets out of it depends very much on how much effort one puts into looking at it. But as the Cone sisters discovered, the challenge of really seeing Matisse is worth the effort, not least because his painting opens us to a unique experience of how pictures can have a plenitude of meanings in intensely visual terms. The challenge of seeing Matisse involves reconciling his obvious surface charm—the bright colors, the pleasing patterns, the agreeable subjects—with his pictorial complexity and psychological subtlety. This is a challenge that he has presented to viewers since he first began to be known about 1905.

From early in his career Matisse inspired very different, often contradictory reactions. At first, conservative critics attacked him for the unprecedented roughness of his works, and, like Gustave Courbet and Édouard Manet before him, he was called "an apostle of ugliness." But with the rise of cubism and related movements, avant-garde critics began to make the opposite accusation, that his pictures were too pretty. He then came under attack for being a mere decorator, and an old-fashioned one at that, because of his insistence on working directly from nature and having his paintings look more or less like the things they represented. After his brief fauve period (1905–6), when he painted in bright, loosely brushed colors, Matisse seemed oddly removed from the concerns of the rest of the European avant-garde. Because he appeared to have no explicit theoretical program, he could

no longer be identified with any of the "isms" into which modern art was being so conveniently divided. His works were stylistically diverse and seemed puzzlingly unsystematic.

And so they may seem at first to the viewer of our day. But when we look at a large body of his works, such as those in The Cone Collection at The Baltimore Museum of Art, we sense that a number of essential elements guided his pictorial thought and gave coherence to his stylistic diversity. For one, more than any other major artist of the twentieth century, Matisse rooted his art in his direct perceptions of the world around him. And for him, confronting the world before his eyes always involved questions of how to extract meaning from what he saw. His work is poetical and imaginative, but his imagination took its cues from his visual experience. The poetics of his work grows out of the way he reinvented what he saw as part of the process of trying to perceive and record it in a meaningful way—what might be called a poetics of vision.

That is why, when we look at Matisse's work, we must pay careful attention to detail. We have to be alert to the body and texture of the paint as well as to the placement of the forms, to the visual rhymes and formal relationships between the people and things that are represented as well as to what the objects are. Matisse himself said, "I do not paint things, I paint only the difference between things."[2] When we look at his paintings, our attention is often deflected away from things almost as much as it is focused on them. Many of Matisse's best pictures constantly shift the viewer's attention from one part of the picture to another and constantly alter the viewer's sense of what is most important. Matisse's paintings usually

2 Louis Aragon, "Matisse-en-France," in *Henri Matisse dessins: thèmes et variations* (Paris: Martin Fabiani, 1943), p. 37.

avoid anything like a "focal point," because they are organized in such a way that one thing always acts as a foil for something else. Wherever you look, you should also be looking somewhere else at the same time. While you are looking at the figure of the woman in *Small Rumanian Blouse with Foliage* of 1937 (PL. 1), you realize that you ought also to be looking at the large leaves that surround and seem to be growing out of her. While you are looking at the leaves, you notice that the dynamism of the floral pattern on her blouse acts as a displaced sign for the force that makes the leaves grow; its quick strokes and bright colors seemingly embody the energy of growth itself. But as soon as you understand that, the reds in the blouse draw your attention to the vivid red accent on the wall behind her, which in turn, you suddenly realize, is part of a painting-within-the-painting, of another woman dressed in a blue blouse. A steep diagonal then draws your eye down and you become aware of the small potted plant that rises from a sea of brown—as if growing out of the earth-colored area of table and floor and sprouting forth earth-colored blossoms. And so on. Everything you look at affects the significance of everything else, and everything has a synergetic relationship to everything else. Everywhere you look, the relationships between things are constantly in flux, and the usual hierarchies between the animal, the vegetal, and the mineral have become remarkably fluid.

One of the ways by which paintings traditionally communicate the significance of what they represent is by the inclusion of objects that have specific conventional meanings (such as a lily standing for purity or an hourglass for time). But Matisse, for the most part, eschews such fixed symbolic

meanings, creating instead what might be called symbolically charged situations. The world is conceived as a continuum in which objects and people are seen as being both stable and dynamic, able to exchange or share some of the other's attributes. Things often assume roles that are the reverse of our expectations or define concepts and essences that lie beyond their actual physical limits. For example, an object may be rendered in a way that makes it seem more dynamic than a living creature placed near it, as in *Interior with Dog* of 1934 (see PL. 42), where the table appears more animated than the dog. Or the decorative motifs on inanimate objects may embody the vitality of the living things around them, as does the wallpaper in *Still Life, Bouquet of Dahlias and White Book* of 1923 (see PL. 33).

Because the energy and meanings implicit in things are fluid and individual parts have meaning only in relation to all the others, Matisse's paintings are often difficult to discuss. For when we talk about them, we find that we can focus on only one thing at a time and that our attention to that one element seems to be at the expense of others. This elusive aspect of Matisse's subjects is reinforced when we take into account the way the paint itself is applied. In a painting such as *Small Rumanian Blouse with Foliage,* overtones of meaning, even of urgency, are communicated by the way the transparent washes are played against the more opaque accents of the woman's blouse, or by the way the pencil lines meander in and out of the patch of paint that more or less defines her face—and drift in and away from the edges of the leaves they are supposed to delineate. Here, as in so many of Matisse's paintings, the evidence of the process of painting

plays a crucial role in how and what the forms signify. Passages of dripped paint and areas of visible overpainting give things a fluidity that quite literally translates them into something else. Not simply a woman sitting in front of a plant next to a window, but a Matisse painting in which there are incidentally a woman, a plant, and a window—and in which the blue of the sky seen through that window seems uncannily to have been displaced to an area directly on the floor below her.

Perhaps more than with any other representational painter, Matisse's pictures resist and make a mockery of easy verbal description. More than most painters, too, Matisse took great advantage of the fortuitous discoveries made in the process of laying paint down on canvas. To an astonishing degree, he made meaningful use of the resistance that the process of painting offered to representation. He took it for granted that the very act of trying to record a three-dimensional world on a two-dimensional surface would necessitate distortions and inspire spontaneous formal inventions. In his paintings, there is a strongly felt tension between the instantaneous nature of vision and the somewhat slower process of recording what one sees. Matisse used this tension to balance the contradictions between the way things look and the feelings they inspire. Matisse's facture, or visible evidence of paint application, which is so clearly apparent in the "open" or "unfinished" look of so many of his paintings, plays an important role in the way that he treats objects. The painter's touch becomes an extension of self, and the evidence of that touch throughout the picture "marks" the objects as belonging not to the *real* world but to the *made* world of the artist, in

which things can come together and relate to each other in unexpected ways.

In a very real sense, the deep subject matter of Matisse's paintings can be said to emerge as a kind of third element produced by the interaction between what he painted and how he painted it. This made him acutely aware of intuitive opportunities for expressiveness that were sometimes offered almost by chance: by the way light strikes an object at a given moment, as in the patterned highlights on the eggplant and pot in *Yellow Pottery from Provence* of 1906 (see PL. 9); or by the fleeting look that passes across a person's face, as in *Young Woman at the Window, Sunset* of 1921 (see PL. 26).

One of the paradoxes of Matisse's art is that he was deeply committed to his subject matter yet at the same time took so many liberties with it that it at times seems incidental— serving merely as a point of departure for his feelings: "To paint not the object but the effect it produces," according to the famous maxim of the poet Stéphane Mallarmé. Matisse simply assumed that what he felt about what he saw was deep enough—and true enough—to produce images that can be universally understood even though they are intensely personal. For Matisse, painting was a means of probing the appearance of things to get at their essence. His goal was to extract from the complex flow of visual sensations concise imagery that would both compress and compound their meaning—what he referred to in his 1908 essay, "Notes of a Painter," as the "condensation of sensations" that allows the artist to "give to reality a more lasting interpretation."[3] Part of the challenge of painting was to create imagery that would

3 Henri Matisse, "Notes d'un peintre," *La Grande Revue* 2, no. 24 (December 25, 1908); translated in Jack Flam, *Matisse on Art* (Berkeley and Los Angeles: University of California Press, 1995), pp. 38–39.

imply flux, movement, and duration, even though paint on canvas is a physically static medium.

As you contemplate the paintings in The Baltimore Museum of Art's Cone Collection, you become intensely aware of just how exuberant Matisse's visual imagination was. His handling of color, line, surface, and space is so complex and varied that it literally reinvents his subjects. Seeing so much of Matisse's work together also makes us aware of a number of repeated thematic and formal concerns, which focused and guided his vision. One is constantly struck by how frequently Matisse reworked certain themes and poses, yet how differently he treated the images of the same or similar things in his different depictions of them. He himself was aware of this. Throughout his life, he said, "I have searched for the same things, which I have perhaps realized by different means.... Thus I have worked all my life before the same objects, which gave me the force of reality by engaging my spirit towards everything that these objects had gone through for me and with me.... The object is an actor: a good actor can have a part in ten different plays; an object can play a different role in ten different pictures. The object is not taken alone, it evokes an ensemble of elements."[4]

Sometimes he shows his fascination with the contingent nature of experience, and the wealth of his inventiveness, by representing the same subjects differently on canvases of almost exactly the same size. A number of the paintings in The Cone Collection, for example, are parts of pairs or small groups done from the same motifs. *Still Life, Compote, Apples, and Oranges* of 1899 (see PL. 5), as we shall see, is one of such a pair, as are a number of the paintings from the 1920s.

4 Quoted in Maria Luz, "Témoignages: Henri Matisse," *XXe Siècle,* n.s., 2 (January 1952); translated in *Matisse on Art,* pp. 207–8.

Within The Cone Collection itself, the most striking example of this is Matisse's reworking of the theme of the 1907 *Blue Nude* (see PL. 10) almost thirty years later, in *Large Reclining Nude* (also known as *The Pink Nude)* of 1935 (see PL. 46).

Seeing a number of Matisse's best works together in The Cone Collection makes it clear that his stylistic diversity was the product of an extraordinary freedom of spirit and a remarkable alertness to the world around him, sustained over a long period of time. Not only did Matisse create one of the twentieth century's most complex and varied bodies of work, he was also one of those rare artists whose late work was as original and vital as his early innovations.

Early Works

5 Henri Matisse, "La Chapelle du Rosaire," in *Chapelle du Rosaire des Dominicaines de Vence* (Vence, 1951); translated in *Matisse on Art,* p. 196.

PLATE 2
Still Life with Peaches. 1895.
Oil on canvas. 17 15/16 x 13 1/4 in.
(45.6 x 33.7 cm). BMA 1950.222

Matisse was trained in the naturalistic tradition of the École des Beaux-Arts, which he worked hard to master and then struggled even harder to free himself from. This struggle, he later told an interviewer, "has been the source of the different changes along my route, in the course of which I have searched for the possibilities of expression beyond the literal copy."[5] He wanted to combine the forthrightness involved in working directly from nature with the inventiveness of less naturalistic traditions.

The ideal of forthright presentation is seen right from his earliest works, such as *Still Life with Peaches* of 1895 (PL. 2) and *The Dam at the Pont Neuf* of 1896 (PL. 3). And yet, at the same time that Matisse was painting what he saw as realistically as possible, he also often referred back to earlier masters. *Still Life with Peaches,* for example, owes a good deal to Jean-Siméon Chardin, an eighteenth-century artist whom Matisse had copied at the Louvre. The influence of Chardin

PLATE 3
The Dam at the Pont Neuf. 1896.
Oil on canvas. 11 1/2 x 14 5/8 in.
(29.2 x 37.2 cm). BMA 1950.223

PLATE 4
*The Convalescent Woman (The Sick
Woman).* (1899). Oil on canvas.
18 5/16 x 15 1/8 in. (46.5 x 38.4
cm). BMA 1950.225

is apparent in the tightly constructed pyramidal composition and in the loving attention given to the handling of the paint. This is especially apparent in the rendering of different kinds of textures, ranging from the velvety softness of the peach skins to the different ways the various objects reflect light.[6]

Matisse was a late starter. He turned to painting only after he had finished a law degree, and he remained a student at the École des Beaux-Arts until he was twenty-seven years old. In most of the works he did until about 1898 he was involved in teaching himself how to paint. It was not until about 1899 that he really began to think with the brush, to allow himself to move freely over the surface of his canvases, and to use color in a more imaginative way.

These characteristics are vividly seen in *The Convalescent Woman (The Sick Woman)* (PL. 4), a depiction of Matisse's wife in bed at her parents' home near Toulouse at the time of the birth of their first son (Jean, born on January 10, 1899). One of the most boldly executed of Matisse's early paintings, it is also an excellent instance of the subtle ways in which he suggested psychological tension. The woman's isolation is exaggerated by the way we are physically blocked from access to her by the table and empty chair, thus deflecting our view away from the nominal main subject of the picture. What seems at first to be a kind of bravura formal exercise in pure painting turns out to have strong psychological over-tones, which remain just on the edge of our consciousness. This is a telling example of how Matisse was able not only to balance form and subject but also to create a synergetic relationship between them. The form creates a mood and thereby reinforces the subject; it also distracts us from some

6 If *Still Life with Peaches* is artful and mindful of history, *The Dam at the Pont Neuf* is something like the opposite. The composition has a surprising awkwardness, which seems to come directly from the unpicturesque nature of the motif itself: a utilitarian dam set in close proximity to a famously beautiful bridge. As if to emphasize the rawness of what he sees, Matisse sets the embankment in a curiously flat way in the lower right side of the picture. Curiously, almost thirty years later he used a similar compositional format, and even a similarly dappled paint application, in *Seascape at Antibes* of 1925 (reproduced in Galerien Tannhauser, *Henri-Matisse* [Berlin and Lucerne, 1930], p. 29), in which the embankment in the foreground describes an even more attenuated arc and is even more dramatically flattened.

FIG. 1
Henri Matisse. *Sideboard and Table*. 1899. Oil on canvas. 26 1/2 x 32 1/2 in. (67.5 x 82.5 cm). Private collection, Switzerland

of the more obvious implications of that subject. A similar tension between revealing and hiding underlies a good deal of Matisse's art.

It was at this time that Matisse became intensely aware of the contingent nature of vision itself and began to do second versions of certain paintings. One of the earliest instances of this is seen in *Still Life, Compote, Apples, and Oranges* of 1899 (PL. 5). Shortly after he had finished it, Matisse did a variation of it on a canvas almost exactly the same size, *Still Life with Oranges (II)* (PL. 6). Moreover, the same still-life setup seems to have been used for *Sideboard and Table* (FIG. 1), a slightly larger canvas rendered in a neo-impressionist manner. A wonderful little pencil drawing (FIG. 2) reveals just how thought-out and calculated these seemingly casual compositions were. In the drawing, Matisse marked a number of rhythmic diagonal relationships between the main sections of the composition and arranged the fruit and other objects in a slightly different way.

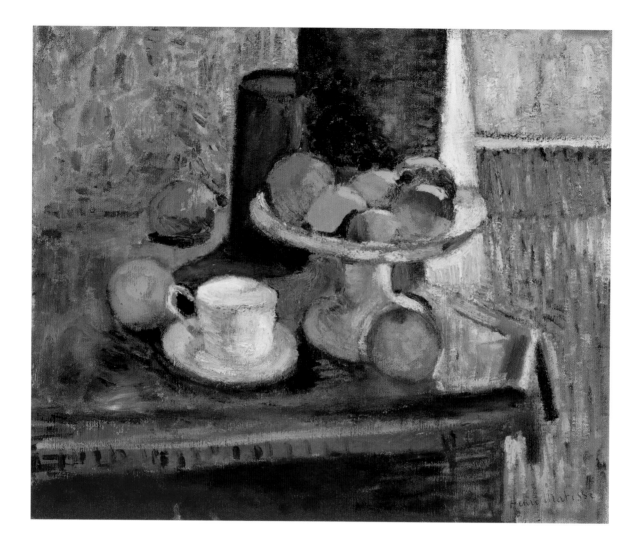

PLATE 5
*Still Life, Compote, Apples, and
Oranges.* (1899). Oil on canvas.
18 1/4 x 21 7/8 in. (46.4 x
55.6 cm). BMA 1950.224

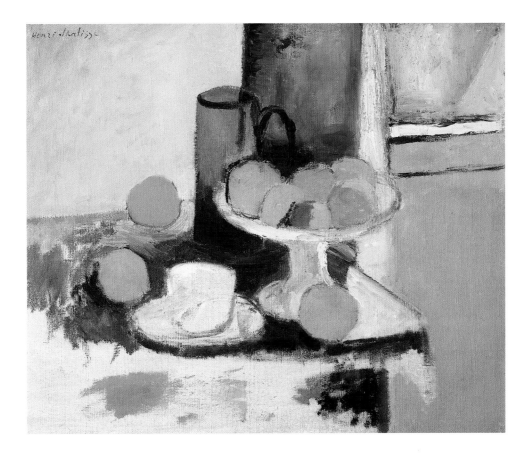

PLATE 6
Still Life with Oranges (II). 1899.
Oil on canvas. 18 3/8 x 21 3/4 in.
(46.7 x 55.2 cm). Washington
University Gallery of Art,
St. Louis. Gift of Mr. and Mrs.
Sydney M. Shoenberg, Jr., 1962

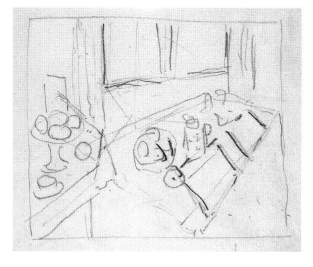

FIG. 2
Henri Matisse. *Still Life.* (1899).
Graphite. 4 5/8 x 5 1/4 in. (118 x
134 mm). The Baltimore Museum
of Art: Gift of Mrs. F. R. Johnson.
BMA 1968.12

The pairing of the Baltimore and St. Louis paintings is
a fascinating one. Although the Baltimore painting is more
naturalistic, it, too, employs chromatic contrasts and is
composed of intricately patterned brushstrokes that modulate
and color the light that flows through the window. In this
painting the corner of the sideboard is truncated, as it is in
the pencil drawing, and in *Sideboard and Table* (and as it
presumably was in real life). In the St. Louis canvas, where
the whole painting is characterized by a sense of edginess,
Matisse rendered this corner as a right angle seen in sharp
perspective. The bright colors in that painting are based on
the fairly vivid hues in the Baltimore painting, but now
exaggerated into an intensely flattened, more decorative kind
of composition. And here, instead of color describing light,
color is used to create light. The objects on the table do not
cast shadows, as they do in the Baltimore painting, and the
whole image is more ethereal. The ideas suggested by such a
structural use of color seem to have been somewhat beyond

7 The signature in any event appears to have been added later. See Jack Flam, "Henri Matisse: *Still Life with Oranges (II),* c. 1899," in Joseph D. Ketner and Jane E. Neidhardt, eds., *A Gallery of Modern Art at Washington University in St. Louis* (St. Louis: Washington University Gallery of Art, 1994), pp. 74–75.

Matisse at this time, and the St. Louis painting was probably left unfinished.[7] The combination of the painterly finesse of the Baltimore picture, the systematic pointillism of *Sideboard and Table,* and the bold flatness of the St. Louis picture provide an excellent instance of the variety of approaches that Matisse employed at this time, even when working from the same still life.

A similar tension between varying modes of perception and different approaches to similar subjects is also evident in Matisse's sculptures of this period. *The Serf* (PL. 7), which Matisse began in 1900 and worked on for several years, was his first major freestanding sculpture. In *The Serf,* the man stands solidly on the ground and there is a good deal of spatial interaction between the figure and the empty space around it. Matisse did not work the surface of his forms illusionistically, in terms of underlying muscle, bone, and flesh. Instead, he used the clay as a malleable plastic material that may intermittently refer to muscle, bone, and flesh but one that always insists on its own irreducible earthiness. Thus, as in Matisse's paintings, the abstract pictorial means of the sculpture are used descriptively but not illusionistically. This is especially evident in the way Matisse scraped and gouged into the form to create a broad range of surface textures that are the sculptural equivalents of the painterly effects he employed in such paintings as *The Convalescent Woman.*

In *Madeleine I* of 1901 (PL. 8), Matisse took a very different approach. Here the undulating, serpentine line that dominates the movement of the woman's body emphasizes her femininity. In contrast to the massive stolidity and inner drive of the portraitlike *Serf,* the figure in *Madeleine I* rises sinuously

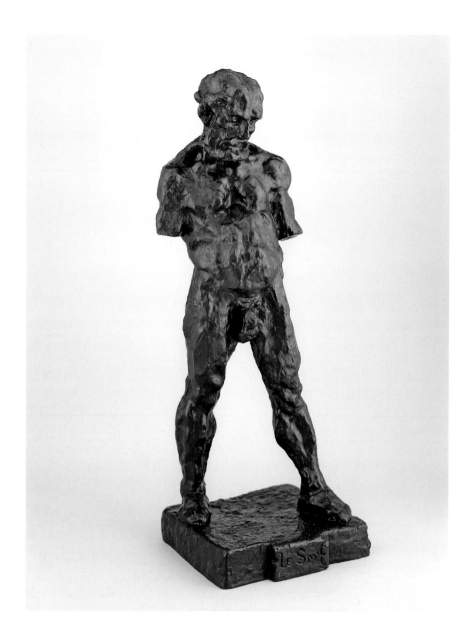

PLATE 7
The Serf. (1900–1903). Bronze;
cast 2/10. 36 1/8 x 11 1/4 x 13 1/16
in. (91.8 x 28.6 x 33.2 cm).
BMA 1950.422

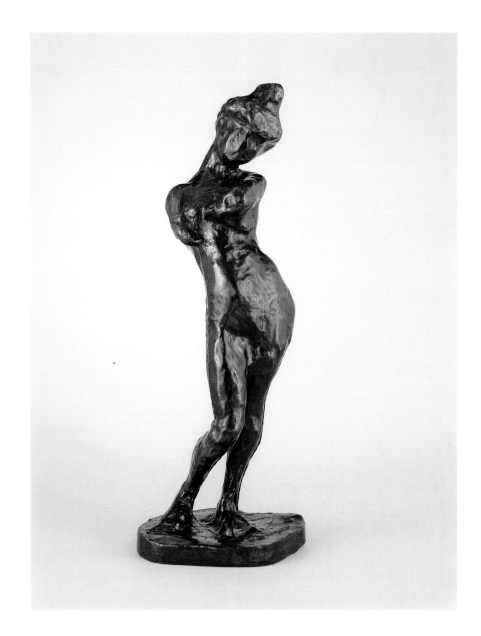

PLATE 8
Madeleine I. (1901). Bronze;
cast 3/10. 23 1/4 x 8 3/4 x 7 1/8 in.
(59.1 x 22.2 x 18.1 cm). BMA
1950.423

from her curved base. The smooth modeling further enhances the woman's litheness, and the organization of the pose in terms of the traditional *figura serpentina* plays down her individuality and makes her movement seem subject to forces outside herself.

Matisse's early sculptures contain complex interactions between illusion and materiality, opticality and tactility, anatomical reference and formal inventiveness. As our eyes move over the sculptures we find that we must constantly shift mental gears to accommodate the contradictory signals that are being given off by these various elements. As in Matisse's paintings, we are constantly aware of the interrelationships between the nominal subject, the artist's emotional response to that subject, and the manipulation of the material for its own sake. It is this sense of process, with its attendant lack of "resolution" and "unsculptural" sense of spontaneity, that makes Matisse's early sculptures so interesting, so provocative, and so important within the history of twentieth-century sculpture.

The expressive possibilities inherent in lack of finish and in emphasizing process came to Matisse largely from Paul Cézanne. This kind of *non finito* is seen in *Yellow Pottery from Provence*, 1906 (PL. 9), the only oil painting in The Cone Collection from Matisse's fauve period. The areas of unpainted white ground give the painting an open and airy quality, which emphasizes the bounty of the vegetables shown on the dish, even though those vegetables are summarily rendered. It is as if the vitality of the eggplants and peppers is to some degree displaced into the swelling and generous form of the pitcher above them. The upward movement is further emphasized by the background forms, giving this modest still life, despite its lack of finish, a quiet majesty.

PLATE 9
Yellow Pottery from Provence.
(1906). Oil on canvas. 21 7/8 x
18 3/8 in. (55.6 x 46.7 cm). BMA
1950.227

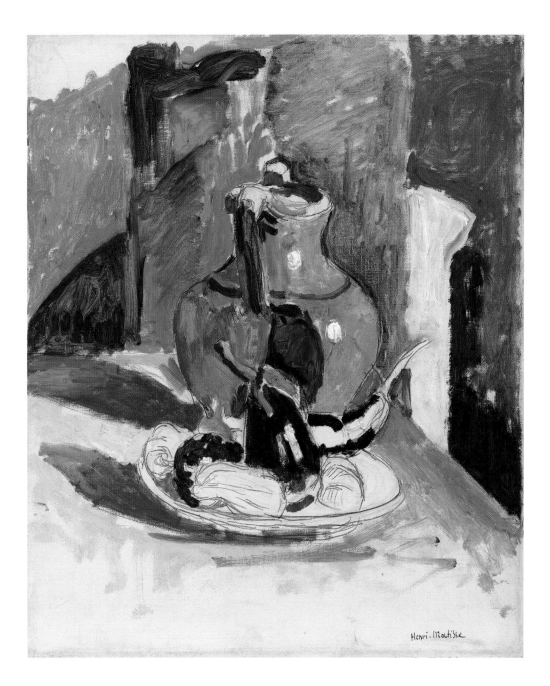

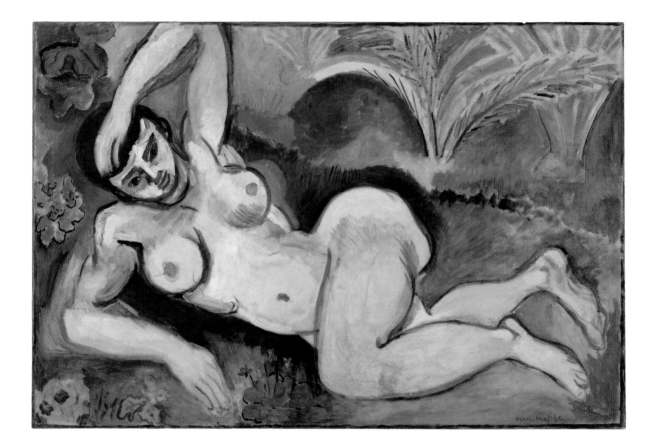

PLATE 10
Blue Nude. (1907). Oil on
canvas. 36 1/4 x 55 1/4 in. (92.1 x
140.4 cm). BMA 1950.228

Blue Nude and Related Sculptures

8 Alfred H. Barr, Jr., *Matisse: His Art and His Public* (New York: The Museum of Modern Art, 1951), p. 87. The Cézannist phase in Matisse's art came well ahead of the explosion of interest in Cézanne's work among other artists, which followed the exhibition of the recently deceased master's watercolors and oil paintings in 1907. This aspect of Matisse's early work, and indeed his frequent identification with Cézanne, became obscured by the subsequent rise of cubism. But at the time, Matisse was the preeminent Cézannist among the younger French painters.

9 On Matisse's use of photographs for his sculptures, including *Reclining Nude I, (Aurore)* see the numerous examples in Isabelle Monod-Fontaine, *The Sculpture of Henri Matisse* (London: Thames and Hudson, 1984), pp. 13–17.

About 1907 Matisse became preoccupied with questions of pictorial structure, especially those that had been posed by the late paintings of Cézanne. He was, as Alfred Barr has remarked, a "premature Cézannist," and at that time probably had the most profound understanding of Cézanne's art among living artists.[8] Nowhere is this better seen than in *Blue Nude* (PL. 10), one of Matisse's greatest paintings.

Blue Nude was painted at Collioure, a French Mediterranean fishing village near the Spanish border, at the beginning of 1907. Matisse had spent the two previous summers there, and in the fall of 1906 he decided to return to Collioure to work for part of the winter. One of his first undertakings was an ambitious sculpture, *Reclining Nude I (Aurore)* (PL. 11), in which he departed from his usual procedure of using a model and worked instead from memory and imagination—and also from photographs, which he used for a number of works at this time.[9]

After Matisse had been modeling the sculpture in clay for several weeks, the piece fell and was badly damaged. Before he took it up again, he decided to do a painting of the same subject. *Blue Nude* is in certain ways a very sculptural painting, in that the forms are intensely modeled, but the means by which three-dimensionality is achieved are very painterly and owe much to Cézanne. This is especially evident in the color, the fluidity of the space, and the expansiveness of the forms.

The composition is based on a series of echoing arcs and curves that relate the woman to the surrounding landscape and emphasize the exchange of energy between her and the earth. The paint application is vigorous throughout, the modeling rough and full of abrupt transitions. The upper and lower parts of her torso, for example, are turned so extremely in relation to each other that they appear to belong to different poses, but they are held together by the way the forms of her body expand outward into the area around them. The bluish pentimenti that radiate from her body give especial amplitude to her arms, breasts, buttocks, and legs. Many of these "pentimenti," moreover, are actually exaggerated by over-painting, to give the figure a heightened sense of vibrancy and force. This is particularly so in the area around the arms and breasts, where the spatial fluidity seems to anticipate cubism. The different degrees of tangibility created by the different kinds of brushwork and overpainting enhance the sense of flux and dynamism, and of reciprocal materialization and dissolution of form, in the painting as a whole. The root-like form of the woman, at once contained by and bursting from the confines of the earth, is like a personification of the forces around her.

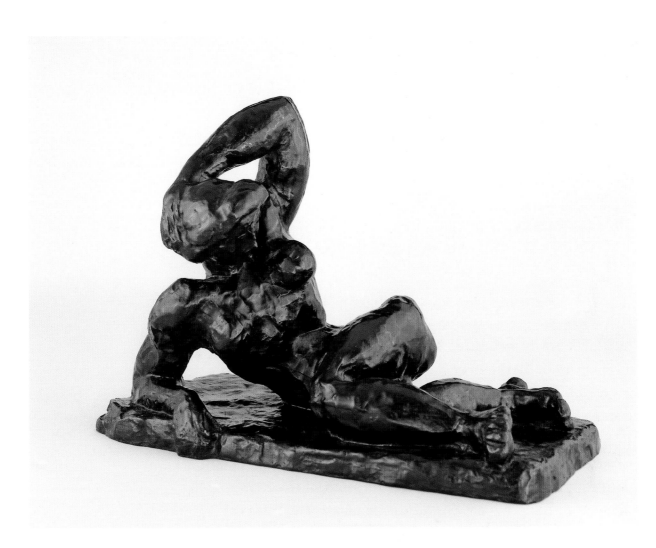

PLATE 11
Reclining Nude I (Aurore). (1907).
Bronze; cast 6/10. 13 9/16 x
19 5/8 x 11 in. (34.5 x 49.9 x
28 cm). BMA 1950.429

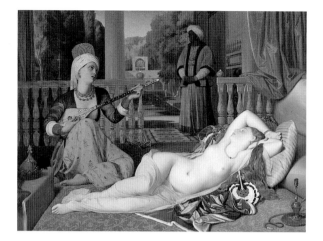

FIG. 3
Jean-Auguste-Dominique Ingres. *Odalisque with Slave*. 1842. Oil on canvas. 30 x 41 1/2 in. (76 x 105.4 cm). The Walters Art Museum, Baltimore 37.887

In *Blue Nude* Matisse seems to have realized more fully than before something that was to be a guiding principle throughout the rest of his career: the degree to which the disposition of forms over the surface of the painting could be conceived as having symbolic as well as pictorial value, even though that symbolic value was inextricable from the formal structure of the picture. In this sense, *Blue Nude* is a prime example of Matisse's thinking with the brush, a seminal painting in which he worked out a number of the essential ideas underlying his art. Significantly, it was the only painting that Matisse sent to the 1907 Salon des Indépendants, where he gave it the cryptic title *Tableau No. III*. This was probably meant to refer to *Blue Nude* as being the third in a series of major imaginative works that he had shown at the two previous independent Salons: *Luxe, calme et volupté* in 1905 and *Le Bonheur de vivre* in 1906.

Blue Nude was a profound response to a number of issues that preoccupied him and other artists about 1907. The woman is symbolic of the primitive intensity and violence of

the land that Matisse had perceived during a recent visit to North Africa, and he makes of her a convincing metaphor for dynamic growth, a kind of modern Venus. As such, the painting is an aggressive rejoinder to the coyly idealized nudes so popular at the time, as well as to neoclassical painting in general. The pose of *Blue Nude* directly alludes to Jean-Auguste-Dominique Ingres's *Odalisque with Slave* (FIG. 3), but the reference is made in a rather contrary way—as a kind of attack on Ingres's cool nudes, which had served as paradigms for many academic painters. The extreme liberties that Matisse took with the woman's body reflected his interest in what he called the "invented planes and proportions" of African sculpture. And, indeed, the African overtones of the painting were later made overt when Matisse described it as a "memory of Biskra," a reference to the oasis in Algeria that he had visited the previous spring.[10] This evocation of Biskra was not meant as a literal memory of something that had happened to him there, but rather as a symbolic image of the powerful way that Biskra had acted on his imagination. He later remembered the place as "a superb oasis, a lovely and fresh thing in the middle of the desert, with a great deal of water that snaked through the palm trees, through the gardens, with their very green leaves, which is somewhat astonishing when one comes to it through the desert."[11] The figure in *Blue Nude,* which personifies the voluptuous growth that had so impressed Matisse in North Africa, is a kind of personification of the force of life itself.

When *Blue Nude* was first shown, the rough handling of the paint and the uningratiating representation of the figure were severely criticized. "A nude woman, ugly, spread out

10 The subtitle *Souvenir de Biskra* was apparently first used in public when the painting was shown at the 1931 Matisse retrospective at the Georges Petit gallery. See Galeries Georges Petit, *Henri Matisse, 16 juin–25 juillet 1931* (Paris, 1931), p. 15, no. 17.

11 Quoted in Pierre Courthion, "Conversations avec Henri Matisse," unpublished typescript of 1941 interviews, Getty Center for the History of Art, Los Angeles, p. 100.

on opaque blue grass under some palm trees," one critic wrote, adding that the drawing appeared "rudimentary and the colors cruel," and noting an "effort here of art tending toward the abstract."[12] (In response to such criticisms, Matisse told someone, "If I met such women in the street, I should run away in terror," adding, "Above all, I do not create a woman, *I make a picture.*")[13] Gertrude Stein, who with her brother Leo had bought the painting from the 1907 Salon, at a time when Gertrude was especially friendly with Etta Cone, enjoyed the shock effect it had on their visitors. She later recalled that "when the casual stranger in the aggressive way of the casual stranger said, looking at this picture, and what is that supposed to represent," she liked to tell how the five-year-old son of their concierge had jumped into her arms when he first saw it and "cried out in rapture, oh là là what a beautiful body of a woman."[14] Nor did the controversy surrounding this aggressive painting die down quickly. When *Blue Nude* was exhibited at the Armory Show in 1913, students at the Art Institute of Chicago burned it in effigy. And when Claribel Cone purchased the painting at the John Quinn estate sale in 1926, it was still a daring acquisition. Only a few years before, the poet William Carlos Williams had contrasted the sensuality of *Blue Nude* to American puritanism, causing him to reflect that "No woman in my country is naked except at night."[15]

After Matisse finished *Blue Nude,* he returned to *Reclining Nude I,* as if to address some of the same pictorial problems in a directly sculptural fashion. *Reclining Nude I* is one of Matisse's most dissonant sculptures, characterized—like *Blue Nude*—by extreme anatomical distortions and abrupt

12 Louis Vauxcelles, "Le Salon des Indépendants," *Gil Blas,* March 20, 1907, p. 1.

13 Henri Matisse, "Notes d'un peintre sur son dessin," *Le Point,* no. 21 (July 1939); translated in *Matisse on Art,* p. 132.

14 Gertrude Stein, *The Autobiography of Alice B. Toklas* (1933; New York: Modern Library, 1993), p. 23.

15 William Carlos Williams, "A Matisse," *Contact II,* 1921; reprinted in E. M. Rosenthal, ed., *The William Carlos Williams Reader* (New York: New Directions, 1966), p. 395.

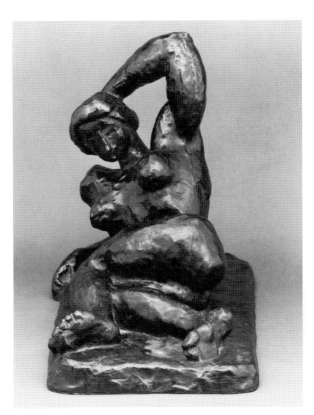

turnings of form in space. In fact, the view from which this sculpture is usually photographed is a relatively sedate one. When it is seen instead from directly above, or from beneath the feet (FIG. 4), the figure projects a primeval roughness and violence.

The next ten years constituted one of the most varied and complex times in Matisse's entire production. Although The Cone Collection does not have any paintings from this period, one does get some sense of the diversity of Matisse's work at this time by looking at sculptures such as *Two Negresses* of 1907–8 (PL. 12), which is notable for the compactness and density of its structure, and *La Serpentine* of 1909 (PL. 13),

which is composed in terms of a strikingly original linearity. Rather than being done from live models, both of these sculptures were based on photographs. For *Two Negresses* Matisse used a magazine photograph of two "Tuareg girls" (FIG. 5), which, although initially described as having come from an ethnographic magazine, is obviously a posed studio shot.[16] When Matisse did this sculpture, he was very much interested in African art, and the negritude of *Two Negresses* is evident not only in the African subject but also in the style. The proportions of the figures, the strong vertical axes, the separated hemispherical breasts, and the distinctive cleavage between the buttocks are all typical of Fang and Baule sculpture, with which Matisse was familiar.

Two Negresses is an excellent example of how important it is to see Matisse's sculptures from all sides. Although it is almost always reproduced from the same viewpoint as the one in the photograph Matisse based it on—and this was so even before the existence of the photograph was known—the view from the opposite side, as in Plate 12, is probably the more interesting one. On the less-looked-at side, the rhythmic elements are more emphatic, different formal rhymes are emphasized, and the physical relationship between the two women seems more intimate. When the piece is seen in profile, yet another feeling is conveyed by the way the two heads lean away from each other, almost as if they are rising from a single body.

La Serpentine shows us just how drastically Matisse could reinvent images taken from photographs.[17] The sculpted figure started out rather naturalistically and was quite robust, following the heavyset woman in the photograph Matisse used

16 This photograph was first published in Albert Elsen, *The Sculpture of Henri Matisse* (New York: Harry N. Abrams, 1972), p. 84.

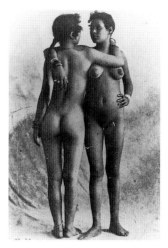

FIG. 5
Magazine photograph of two Tuareg women on which Matisse based his sculpture *Two Negresses*. Photo Archives Matisse, D.R.

PLATE 12
Two Negresses. (1907–8). Bronze; cast 4/10. 18 3/8 x 9 3/4 x 8 in. (46.7 x 24.8 x 20.3 cm). BMA 1950.430

17 *La Serpentine* also contains an ironic art-historical reference, already present in the photograph he used, to the well-known image of the Farnese Hercules. This reference further complicates the already charged sexual implications of the piece.

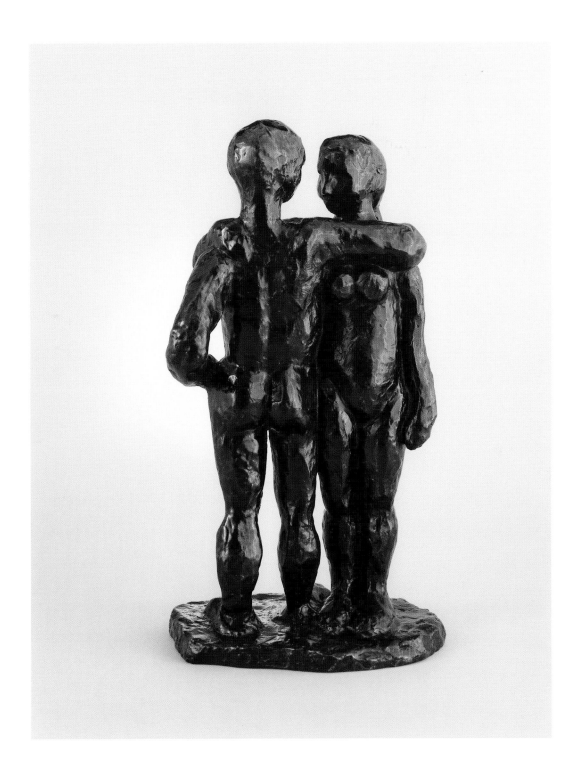

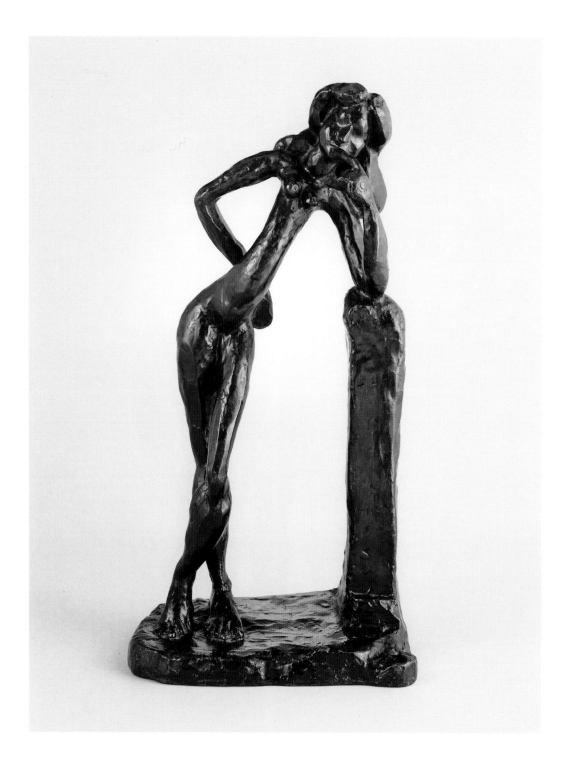

(FIG. 6). But he severely pared down the figure, creating one of his most open sculptures. As he translated the figure into an ensemble of lyrical curves twisting through space, freeing the forms from literal anatomical references, he also created a striking metaphorical image. The woman, who is rendered like a plant growing out of the ground, relates to the base in a striking way. Her pose is reminiscent of antique sculptures, in which figures lean against trunks of trees. But here she herself is like a plant, while the base is a phallic form against which the lyrical sinuousness of her body is played. The image thus contains an intriguing dialogue between male and female elements.

La Serpentine is a very radical piece of sculpture, extraordinarily open, composed as much with empty spaces as with sculptural masses. In fact, it is hard to think of any previous modern sculpture in which volume is so boldly translated into line or that makes such an extreme use of spatial transparency. *La Serpentine* also relates directly to Matisse's painting of the period, coinciding with *The Dance* of 1909, which contains his most openly linear painted figures. The woman in *La Serpentine,* in fact, seems to be dancing while standing still, and the title may indeed contain a subtle pun in its simultaneous reference to the winding sinuousness of her body and to Loïe Fuller's celebrated dance of the same name.

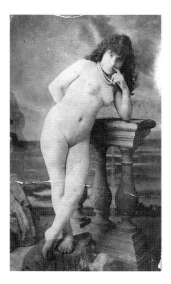

FIG. 6
Magazine photograph on which Matisse based his sculpture *La Serpentine*. Photo Archives Matisse, D.R.

PLATE 13
La Serpentine. (1909). Bronze; cast 3/10. 21 1/2 x 11 1/2 x 7 1/2 in. (54.6 x 29.2 x 19 cm). BMA 1950.93

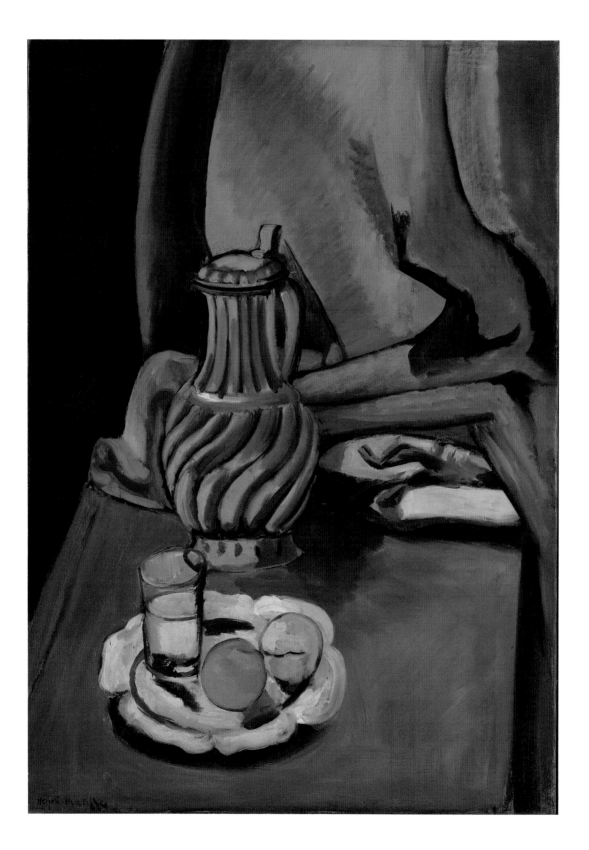

The Early Years in Nice

18 In 1916 Matisse and the painter Albert Marquet visited Monet at Giverny, and at the end of 1917 Matisse would visit Renoir at Cagnes.

Between 1908 and 1916, many of Matisse's paintings were marked by an extreme severity and a strong tendency toward abstraction. From about 1917 through the 1920s, however, he worked in a more naturalistic manner, and these paintings are especially well represented in The Cone Collection. The psychological tensions created by World War I and by marital difficulties seem to have contributed to this change, which was accompanied by a renewed interest in such nineteenth-century French masters as Manet, Claude Monet, and Pierre-Auguste Renoir.[18] Matisse's interest in Manet is clearly reflected in *The Pewter Jug* of 1917 (PL. 14), which combines simplified forms with virtuoso optical effects. This is especially evident in the wonderfully concise rendering of the reflection of the fruit on the side of the jug, and in the subtle conflation of the curved edge of the plate and the curved line of the water in the glass. Even the difficult legibility of the objects just to the right of the jug recalls the blend of extreme

clarity and unexpected representational ambiguity that we often see in Manet's paintings. The same distinctive pewter jug would appear in later drawings and paintings as a very specific kind of "actor," most notably in *Purple Robe and Anemones* of 1937 (see PL. 47).

In late 1916 and 1917 Matisse did an extended series of portrait-like paintings of an Italian model named Lorette dressed in various kinds of exotic clothes, occasionally including North African costume. *Woman in Turban (Lorette)* of 1917 is one of a handful of pictures in which Lorette wears such exotic headgear (PL. 15). In the Cone painting, Lorette is represented with a severe face and a probing stare, whereas in other paintings in the series she is seen alternately as girlish, sensual, coquettish, or simply bored. A similar fascination with the changing moods of a young woman is evident in the famous *Plumed Hat* series of paintings and drawings that Matisse did from a model named Antoinette Arnaud in 1919. In *Girl with Plumed Hat in Profile* (PL. 16), Antoinette's eyes are mysteriously hidden by her elaborate hat, and her body is suffused with a relaxed sensuality. In *The Plumed Hat* (PL. 17), where the rendering is more modeled and detailed, she is seen full front wearing an embroidered blouse, and she seems girlishly innocent.

When Matisse did *The Plumed Hat* drawings he was already spending most of his time in Nice. He first went there toward the end of 1917, in a somewhat restless state of mind, seeking new surroundings and a break from his domestic routine. Although he initially intended to stay only for a short while, he found the light and atmosphere there inspiring and ended up spending most of the rest of his life in the area.

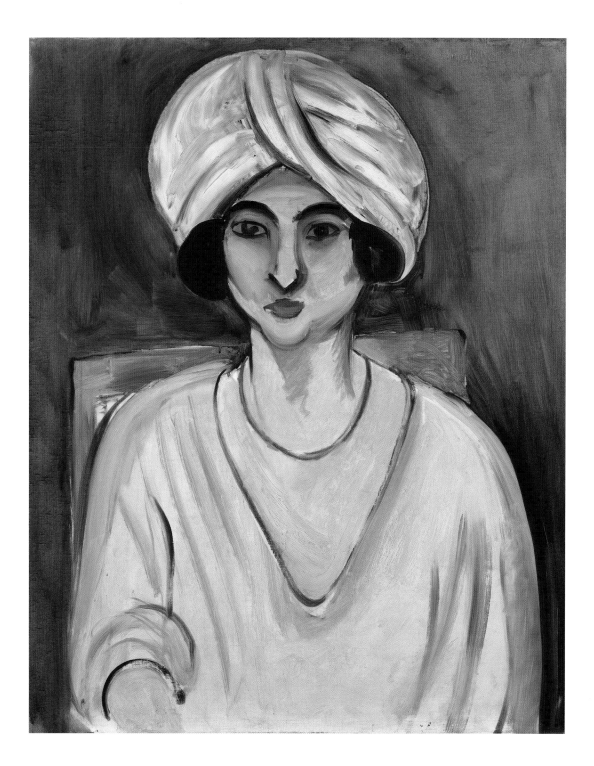

PLATE 16
Girl with Plumed Hat in Profile.
(1919). Graphite. 14 5/8 x
9 3/4 in. (372 x 246 mm). BMA
1950.12.41

PLATE 17
The Plumed Hat. (c. 1919).
Graphite with erasing. 19 3/8 x
14 5/8 in. (491 x 370 mm). BMA
1950.12.58

PLATE 18
Painter in the Olive Grove. (1922).
Oil on canvas. 23 3/4 x 28 7/8 in.
(60.3 x 73.4 cm). BMA 1950.239

On the last day of 1917 (his forty-eighth birthday) he was introduced to Renoir (who lived in nearby Cagnes) by the writer George Besson. During the next few months, he paid repeated visits to the older master, and this seems to have quickened his already awakened interest in impressionist painting.

Although Matisse had been doing landscapes since he began to paint, he had done relatively few after 1906. But during his first years in Nice, landscapes that were made directly from nature, which provided him with an occasion for exploring the surrounding countryside, constituted the greater part of his production. Occasionally, as in *Painter in the Olive Grove* of 1922 (PL. 18), the landscapes had people in them, but for the most part they do not. His stylistic approach varied a good deal. The paint handling in *Eucalyptus, Montalban* is especially light (PL. 19), with the foliage enriched by deep blues and bright violets, while linear movements and green tonalities predominate in *The Maintenon Viaduct* (PL. 20). As Matisse became familiar with his new surroundings, he frequently did more than one painting from the same motif.[19]

These landscapes sometimes contain surprisingly direct references to Monet and Renoir. In 1920, for example, when Matisse went to the port town of Étretat on the Normandy coast, he depicted its famous cliffs and rock formations in paintings like *The Pierced Rock* (PL. 21), which clearly evoke not only the subject matter but even some of the compositional formats of Monet's paintings of the same subjects.[20] In *Large Cliff with Fish* of 1920 (PL. 22), Matisse represents a catch of fish placed on a bed of seaweed in the foreground and in the distance the Elephant and Needle rocks that had been

19 A number of the Cone landscapes have pendants in other collections. For example, *Landscape in the Midi* (Columbus Museum of Art, Ohio) depicts almost exactly the same motif as *Eucalyptus, Montalban* on a canvas around the same size. Matisse also did at least one other rendering of the viaduct at Maintenon (published in Guy-Patrice Dauberville and Michel Dauberville, *Matisse: Henri Matisse chez Bernheim-Jeune* [Paris: Editions Bernheim-Jeune, 1995], vol. 1, p. 680).

20 During the 1880s, Monet had painted a number of the same motifs that Matisse depicted. See Daniel Wildenstein, *Monet, Catalogue Raisonné* (Cologne: Taschen, Wildenstein Institute edition, 1996), vols. 2–3, especially nos. 816–817, 832–833, 1035, 1046–1047, 1052.

PLATE 19
Eucalyptus, Montalban. (1918). Oil
on canvas board. 12 7/8 x 16 1/16
in. (32.7 x 40.8 cm). BMA 1950.231

PLATE 20
The Maintenon Viaduct. (1918).
Oil on canvas board. 13 x 16 1/16
in. (33 x 40.8 cm). BMA 1950.232

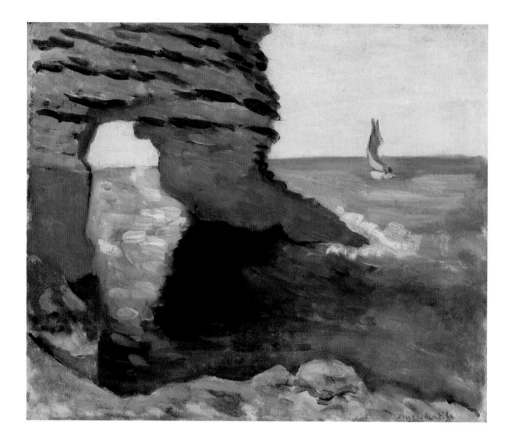

PLATE 21
The Pierced Rock. (1920). Oil on
canvas board. 14 15/16 x 18 in.
(38 x 45.7 cm). BMA 1950.234

PLATE 22
Large Cliff with Fish. (1920). Oil
on canvas. 36 5/8 x 29 in. (93.1 x
29 cm). BMA 1950.233

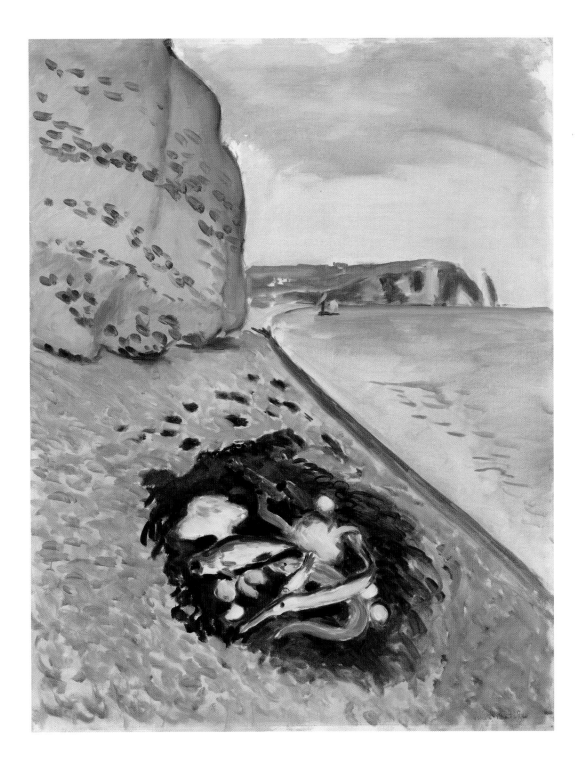

famously painted by Monet (and before him by Eugène Delacroix and Courbet), as if to insist on his position within the mainstream of the French tradition. The space is flattened out and the perspective compressed so as to emphasize the interaction of the shapes of the land and sea. Although the shoreline in *Large Cliff with Fish* defines perspective in a surprisingly insistent way, its concise linearity also asserts the flat surface of the canvas. For all the abstract qualities of this painting, however, Matisse found it very important to have his inspiration sustained directly by the motif. While working on *Large Cliff with Fish* he repeatedly threw water on the fish to keep them lustrous and alive—an example of the degree to which he relied on his motif as a stimulus for his imagination.[21]

Matisse used a similarly plunging perspective in *Festival of Flowers* of 1922 (PL. 23), one of a series of paintings in which he represented women watching the carnival parade on the Promenade des Anglais. Matisse was fascinated by the liveliness and extravagance of the procession, which he rendered in a manner reminiscent of Monet's and Renoir's paintings of Parisian boulevards. Yet at the same time he was also interested in the reaction of the women to the spectacle.[22] The half dozen or so *Festival of Flowers* paintings all employ a similar composition and manner of rendering, but the models are posed quite differently. They wear different clothes, and their attention is drawn to different places, creating different kinds of dramatic effects. In the Cone painting, for example, the women are gazing into a distant area that is out of the viewer's sight, creating a sense of mystery.

21 Matisse told the Cone sisters that he threw the live fish back into the water after he had finished painting them. See Jack Cowart and Dominique Fourcade, *Henri Matisse: The Early Years in Nice, 1916–1930* (Washington, D.C.: National Gallery of Art; New York: Harry N. Abrams, 1986), p. 44 n. 55. He also painted two closely related compositions of similar motifs, *Two Rays* (Norton Gallery and School of Art, West Palm Beach, Florida) and *The Conger Eel* (Columbus Museum of Art, Ohio).

22 Curiously, Matisse later played down his interest in the subject. Exasperated by his models' interest in the festival going on outside the window, and anxious to get in a full day's work, he said, he decided to pose them on the balcony, so they would keep still while he worked. Francis Carco, "Conversations avec Matisse," in *L'ami des peintres* (Paris, 1953); translated in *Matisse on Art*, p. 136.

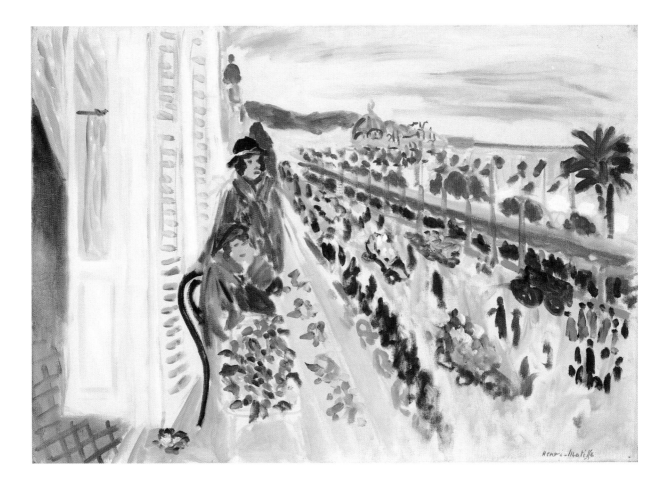

PLATE 23
Festival of Flowers. (1922). Oil on
canvas. 25 7/8 x 36 5/8 in.
(65.8 x 93.1 cm). BMA 1950.240

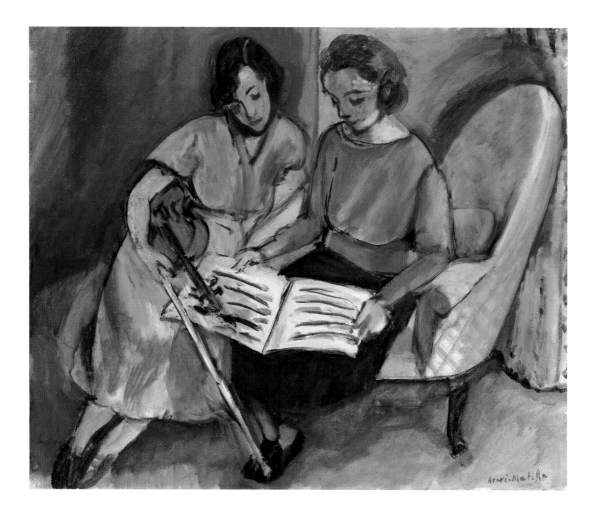

PLATE 24
*The Music Lesson, Two Women
Seated on a Divan.* (1921). Oil on
canvas. 21 9/16 x 25 3/4 in.
(54.8 x 65.4 cm). BMA 1950.242

During the 1920s Matisse frequently painted women in situations where they were not doing anything in particular—in which they are objects of the painter's (and our own) gaze, and often spectators themselves. Although he sometimes painted them engaged in artistic activities (as in *Painter in the Olive Grove* and *The Music Lesson, Two Women Seated on a Divan* [PL. 24]), they more often seem listless and bored. In *Woman in Striped Pullover, Violin on the Table* (PL. 25), the alienation from activity is intensified by the ambivalent relationship between the woman and the instrument; one cannot help wondering whether the violin is even hers.[23] It is tempting to speculate on why the Cone sisters would have been so drawn to pictures like this, which portray the uneasy situation of women being imprisoned within a world of limited possibilities and circumscribed action. One wonders whether they identified directly with the women in these paintings, who—like the Cone sisters themselves—were prepared to play an active role in life but who constantly struggled against being politely but firmly marginalized.

At this time, Matisse was especially fascinated by isolated young women staring off into space, reading, or daydreaming. About 1921 he did a number of paintings of women staring out of windows, such as *Young Woman at the Window, Sunset* (PL. 26), in which we cannot see the direct object of the woman's attention and in which the world beyond the window (despite its specific detail) has an air of unreality. These paintings create a deep sense of unease in the viewer. In part this is because we are to some degree aware that the woman is depicted in the act of posing for the painting that we are looking at, and so we are never quite sure whether we are

23 Matisse was a dedicated amateur violinist, and one is tempted to read the violin as a surrogate for his own presence.

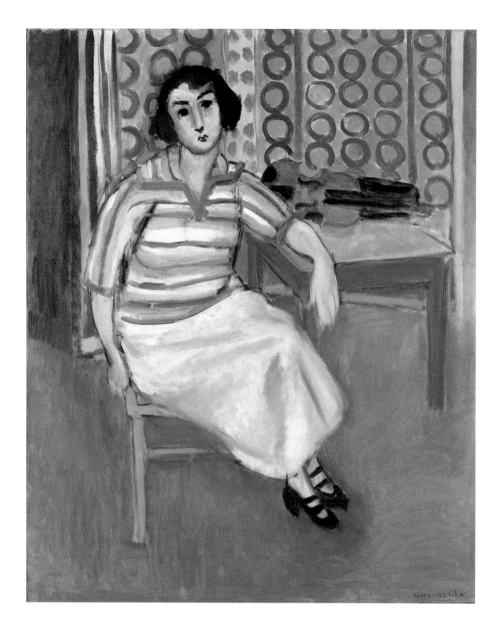

PLATE 25
*Woman in Striped Pullover, Violin
on the Table.* (late 1921–early
1922). Oil on canvas. 28 7/8 x
23 7/8 in. (73.4 x 60.7 cm). BMA
1950.241

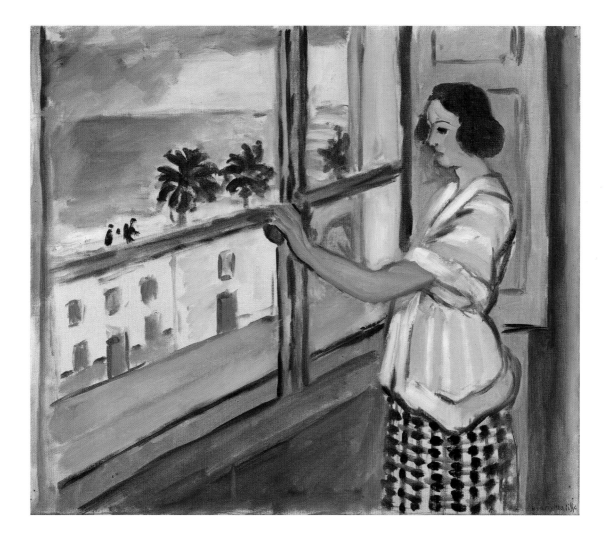

PLATE 26
Young Woman at the Window,
Sunset. (1921). Oil on canvas.
20 5/8 x 23 3/4 in. (52.4 x
60.3 cm). BMA 1950.245

meant to understand her as actually bored and anxious or as portraying someone who is bored and anxious. This kind of psychological double-framing is paralleled by the way in which the frame of the window creates a picture-within-the-picture, suggesting different realms of experience within the same painting.

An even more extreme situation is evoked in the erotically charged *Nude with Spanish Comb, Seated in Front of a Curtained Window* of early 1920 (PL. 27). Here both the woman's nudity and the exoticism of the comb in her hair seem incongruous, given her pose and the banality of her surroundings. The incongruity is intensified by the way the modest gesture of placing her hand in front of her pubic area clashes with the matter-of-fact way in which she stares out at us. If it were not for the Spanish comb, one would be inclined to see her simply as a naked woman who had recently come out of her bath.

The relationship between the exotic and the erotic is especially strong in Matisse's numerous paintings of odalisques. Ever since Matisse had seen a large exhibition of Islamic art at Munich in 1910, he had been intrigued by the decorative aesthetics of Near Eastern and North African cultures. His fascination with that tradition was reinforced by his voyages to Morocco in 1912–13, after which images of women dressed in North African costume began to appear in his work, as we saw in *Woman in Turban* of 1917. But the first true odalisques date from 1919, when Matisse was looking carefully at the art of the previous century and searching for new ways to depict the nude.[24] Part of the problem he faced was the same one that Delacroix had discussed in his journal almost a

24 Among the earliest 1919 odalisques were *The Black Table, Femme vetue à l'Orientale,* and *French Window at Nice,* both now in the Barnes Foundation.

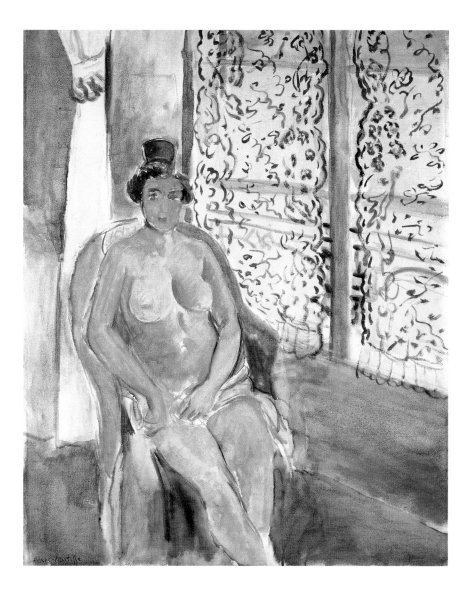

PLATE 27
*Nude with Spanish Comb, Seated
in Front of a Curtained Window.*
(early 1920). Oil on canvas.
28 13/16 x 23 3/4 in. (73.2 x
60.4 cm). BMA 1950.237

century before: given the constraints of modern life, how can one make a nude convincing in a modern painting? Some years later, Matisse told the critic Tériade, "I do odalisques in order to do nudes. But how does one do the nude without it being artificial?"[25] Matisse's involvement with the theme developed only gradually. In 1920, for example, most of the women he painted were not depicted as odalisques; in 1921 there were a few more; after that, they gradually increased in number until, by 1926, most of the women depicted in his paintings were odalisques. And then, quite abruptly, after 1928 they disappeared almost entirely from his work.[26]

Nor did Matisse always aim to be entirely convincing about the exoticness of his odalisques. In *Standing Odalisque Reflected in a Mirror* (PL. 28), for example, the foreignness of the woman's costume is belied by the obviously European chair behind her, which is covered in checked cloth. Similarly, the woman in *Seated Odalisque, Left Leg Bent,* 1926 (PL. 29), is depicted within surroundings that give off very different kinds of cultural significations. Although the woman herself is dressed like a harem girl, she is obviously as French as the chair on which she is seated. And while the moucharaby screen is truly exotic (Matisse had brought it back from Morocco), the red-tiled floor is typical of houses on the Côte d'Azur. Perhaps the most striking combination of conflicting cultural markers is in *Odalisque with Green Sash* of 1927 (PL. 30), which is also the most blatantly erotic of the odalisques in The Cone Collection. Like many of Matisse's odalisque paintings, this is part of a series in which similar studio props are used. The elements of North African costume and decor are played against the very prominent

25 "Statements to Tériade: Matisse Speaks," *Art News Annual* 21 (1952); reprinted in *Matisse on Art,* p. 205.

26 The reasons for this were complicated, but certainly involved his sense that he was getting bad press for them. That he was not unaware of the potential absurdity of the subject is evidenced in a mid-1920s photograph taken of the painter Pierre Bonnard in Matisse's studio, parodying a "Matisse odalisque" pose (see Cowart and Fourcade, *Matisse: The Early Years in Nice,* p. 31).

PLATE 28
Standing Odalisque Reflected in a Mirror. (1923). Oil on canvas. 31 7/8 x 21 3/8 in. (81 x 54.3 cm). BMA 1950.250

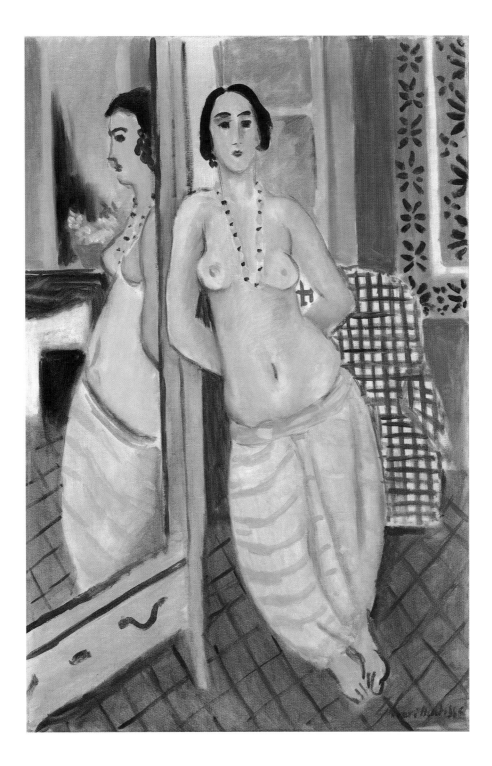

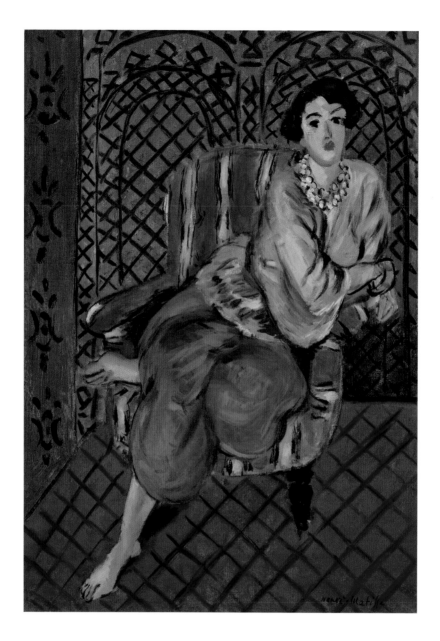

PLATE 29
Seated Odalisque, Left Leg Bent.
(1926). Oil on canvas.
25 3/4 x 18 1/8 in. (65.4 x
46.1 cm). BMA 1950.251

Louis xv table that is rendered in such an animated way that it seems like another living creature. In a closely related painting, *Odalisque with Gray Culottes* (FIG. 7), the table is given much less prominence, the woman does not grasp her own breast, and the overall effect is very different.

In *Seated Odalisque, Left Knee Bent, Ornamental Background and Checkerboard* of 1928 (PL. 31), a strong sense of patterning dominates the picture and to some degree undermines our sense of the scale of the woman relative to her surroundings. Yet at the same time, despite the extreme flatness of the rendering, Matisse paints a cast shadow around the woman's right foot, thus indicating three-dimensionality in an area that is otherwise rendered quite two-dimensionally. The presence of such incongruously tangible moments within such a rigorously decorative painting enhances the unreality of the image as a whole. The embroidered jacket worn by the woman in this painting appears in a number of works done around this time, including a drawing in The Cone Collection, *Reclining Odalisque with Checkerboard* of 1927–28 (PL. 32).[27]

Matisse's orientalism may reflect a growing French interest in exotic cultures after World War I. In 1922, just when the odalisque theme was becoming dominant in Matisse's work, a large Colonial Exposition was held in Marseille, France's traditional gateway to the East. Yet it remains difficult to draw a direct relationship between Matisse's orientalism and French colonialist concerns. In fact, the blatant artificiality of Matisse's depictions of oriental subjects suggests a self-consciousness that might well be characterized as "post-colonialist." To some degree, the parallel between the captive

27 Matisse painted the same model in the same surroundings in a rather different way in *Odalisque with a Turkish Chair,* now in the Musée d'Art Moderne de la Ville de Paris (reproduced in Cowart and Fourcade, *Matisse: The Early Years in Nice,* p. 221).

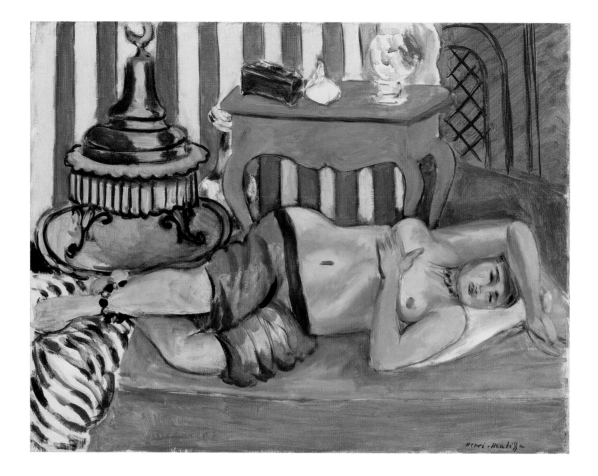

PLATE 30
Odalisque with Green Sash. (1927).
Oil on canvas. 20 x 25 1/2 in.
(50.8 x 64.8 cm). BMA 1950.253

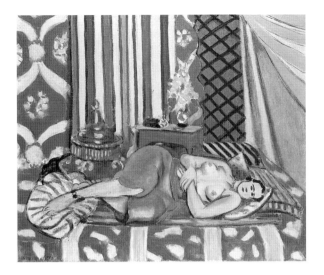

harem woman and the captive artist's model, both "slaves" to the men they serve, emerges as a subtext of this and related paintings. It is the very ambivalence of Matisse's use of these oriental subjects that makes his paintings of odalisques so emotionally ambiguous.

This subtext was something that Matisse himself recognized, and by the late 1920s he had become somewhat defensive about his depictions of odalisques. Only a few months after he painted *Seated Odalisque, Left Knee Bent, Ornamental Background and Checkerboard,* he related the odalisque theme to his experience of Morocco: "I know that they exist. I was in Morocco. I have seen them."[28] Years later, he came closer to the complexity of his motivations when he told the poet André Verdet that the odalisques had been "the fruits of a happy nostalgia, of a lovely, lively dream and of the almost ecstatic, enchanted experience of those days and nights in the incantation of the Moroccan climate." He had, he told Verdet, "felt an irresistible need to express that ecstasy, that

28 E. Tériade, "Visite à Matisse," *L'Intransigeant,* January 14 and 29, 1929; translated in *Matisse on Art,* p. 86. Interestingly, the year before Matisse painted *Seated Odalisque, Left Knee Bent, Ornamental Background and Checkerboard,* he had seriously contemplated returning to Morocco, as if to recapture his prototypical experience of "the Orient." But, perhaps afraid that the real place could not compete with the fantasy that he had built up around it, he decided not to go. (Letters from Henri Matisse to Pierre Matisse, January 1 and March 3, 1927; Pierre Matisse Archives, Pierpont Morgan Library, New York.)

PLATE 31
*Seated Odalisque, Left Knee
Bent, Ornamental Background
and Checkerboard.* (1928). Oil on
canvas. 21 5/8 x 14 7/8 in.
(55 x 37.8 cm). BMA 1950.255

PLATE 32
*Reclining Odalisque with
Checkerboard*. (1927–28). Pen
and ink with scraped corrections.
15 1/8 x 19 7/8 in. (384 x
506 mm). BMA 1950.12.46

divine nonchalance, in corresponding colored rhythms, the rhythms of sunny and lavish figures and colors."[29] It was then that Matisse best described one of the deep lessons that he had learned from Eastern art generally, in words that could be used to describe *Seated Odalisque, Left Knee Bent, Ornamental Background and Checkerboard*:

> The oriental decors of the interiors, all the hangings and rugs, the lavish costumes, the sensuality of heavy, slumbering flesh, the blissful torpor of faces awaiting pleasure, this whole ceremony of siesta brought to maximum intensity in the arabesque and the color must not mislead us: I have always rejected anecdote for its own sake. In this ambience of languid relaxation, beneath the sun-drenched torpor that bathes things and people, a great tension smolders, a specifically pictorial tension that arises from the interplay and mutual relations of the various elements. I eased those tensions so that an impression of pleasant calm could emerge from these paintings, a more or less amiable serenity in the balance of deliberately massed riches....
>
> It was a tranquil period of transition that marked the beginning of another adventure, in the course of which the rhythmic syntax of the picture will be completely changed by the inversion of the relations between forms, figures, and background.[30]

Such "inversions," which would become one of the most salient characteristics of Matisse's late style, are also apparent in some of his 1920s still lifes. In *Still Life, Bouquet of Dahlias and White Book* of 1923 (PL. 33), the objects are rendered boldly and with deep colors, and there is an intriguing interaction

29 Quoted in André Verdet, *Entretiens, notes et écrits sur la peinture: Braque, Léger, Matisse, Picasso* (Paris: Editions Galilée, 1978), p. 124. Verdet interviewed Matisse between 1948 and 1951. It is hard to imagine where in Morocco Matisse might actually have seen "odalisques" except in brothels. If so, the odalisques of the 1920s may evoke a more specifically sexual nostalgia than Matisse liked to discuss.

30 Quoted in Verdet, *Entretiens,* p. 126.

PLATE 33
Still Life, Bouquet of Dahlias and White Book. (1923). Oil on canvas. 19 3/4 x 24 in. (50.2 x 61 cm). BMA 1950.249

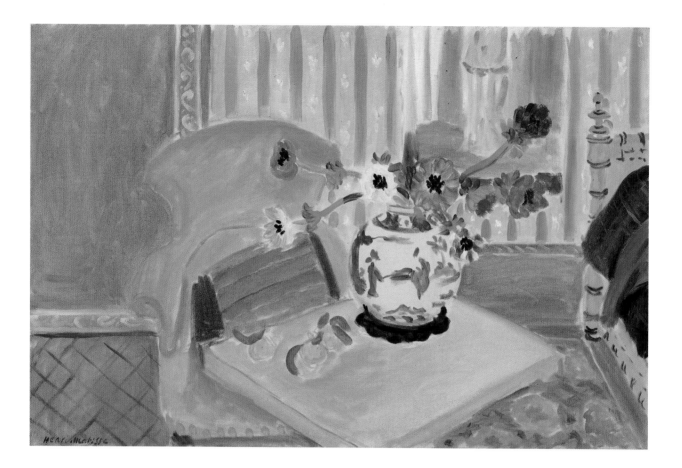

PLATE 34
Anemones and Chinese Vase.
(1922). Oil on canvas. 24 x
36 3/8 in. (61 x 92.4 cm). BMA
1950.248

between the "real" red flowers in the vase on the table and the decorative flowers in the wallpaper that surrounds them. In *Anemones and Chinese Vase* (PL. 34), the flowers are given a very different kind of animation. They are contrasted with the straight and crisscrossing lines in most of the areas around them, and at the same time they are rhymed with the fruit on the table and the floral rug just below them, at the lower right. The energizing contrasts within the painting are epitomized in an especially bold way in the image of the odalisque in the painting on the wall, who seems to rise up from the flowers like an animating goddess.[31]

One of the most mysterious and elaborately staged of all the still lifes Matisse did during this period is *Interior, Flowers and Parakeets* of 1924 (PL. 35). In the foreground is a table with a brightly decorated yellow cloth, a cup, and some fruit with a bouquet of pink flowers. Toward the rear of the table, set against a green Moorish cloth, is a birdcage in which two green parakeets can be discerned, perched above the flowers. The green Moorish cloth is pulled back—a traditional symbol of revelation—to disclose a room beyond. Back in that distant room we see a rug, a decorative screen, part of a chair or sofa, and a prospect through a window—a view through the back of the painting that seems to be uncannily symmetrical to our own view into the front of it. The sensation of containment and extension of vision is further enhanced by the visual transparency of the birdcage, which emphasizes its role as a kind of conduit of viewing, opening as it does both back to the window and forward to the picture plane.

This composition is closely related to other paintings done at the same time, which also invest the here and now with

31 Although the painting is difficult to identify with certainty, it is probably *Odalisque in Blue* of 1921 in the Walter-Guillaume Collection, Musée de l'Orangerie, Paris (reproduced in Dauberville and Dauberville, *Matisse*, vol. 2, p. 1054).

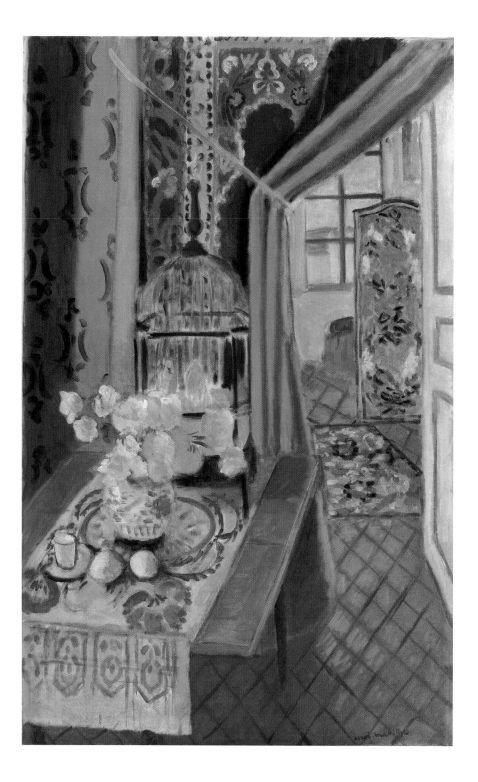

32 In a second related composition, *Woman Reading, Drawn Curtain* (reproduced in Cowart and Fourcade, *Matisse: The Early Years in Nice*, p. 190), a woman sits in the foreground absorbed in a book, and the view through the drawn curtain acts as an evocation of the imaginary world of the book.

hints of ghostly presences. In one of them, *Interior with a Phonograph* (FIG. 8), we see the reflection of Matisse himself in the mirror behind the drawn curtain and off to the right a phonograph with its speaker horn facing directly out at us. The phonograph suggests the passage of time in a way that parallels the painted image in the mirror. Just as the phonograph preserves a record of long-gone utterances, so the painted mirror brings us the ghostlike presence of a long-lost vision—in this case of Matisse himself, represented in the act of painting the picture we are looking at. His image in the mirror is as vivid and as fleeting as a song on a phonograph record, charged with nostalgia, trying bravely to assert some small victory over the ineluctable passage of time.[32]

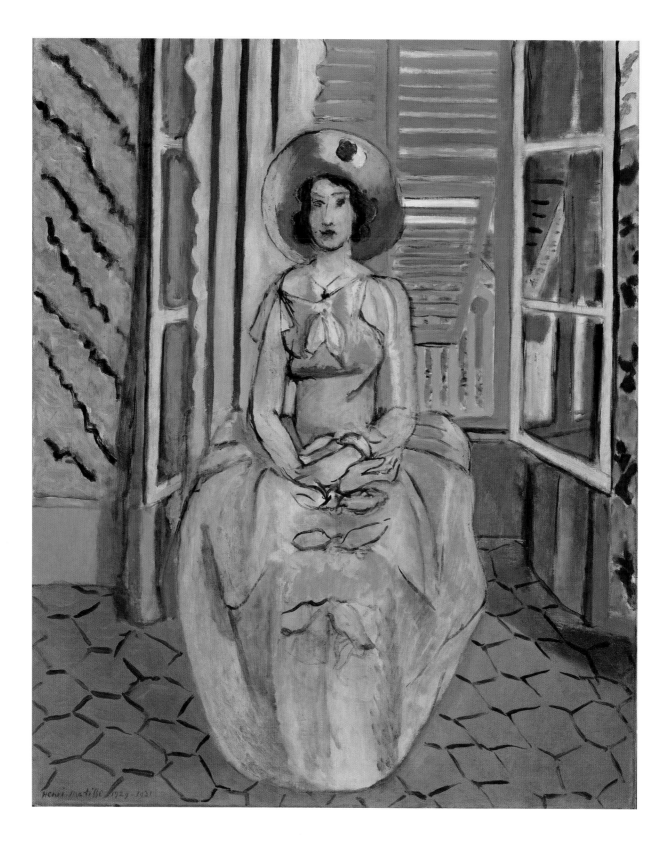

Matisse's Late Style

The Cone Collection provides wonderful insights into the development of Matisse's late style, along with some of the best examples of his work during this period. After the death of her sister in October 1929, Etta Cone became especially alert and receptive to what was happening in Matisse's art. And Matisse, for his part, was intent in working with her to help shape this aspect of the extraordinary collection that she was putting together.

About the time of Claribel's death, Matisse was in the midst of a painting block. His production fell off sharply, and he left a number of paintings unfinished. In September 1929 he began *The Yellow Dress* (PL. 36), which became an important transition to his late style. But after working on it for several weeks, he put it aside; another two years would pass before he could bring it to a satisfactory conclusion. In 1930 he traveled a good deal, to Tahiti and to the United States, where Albert Barnes invited him to do a mural for the

main hall of the Barnes Foundation in Merion, Pennsylvania. Matisse returned to Nice in August 1930. There he took up *The Yellow Dress* again, just before he began the Barnes mural and the illustrations for a book of Mallarmé's poetry that had been commissioned by the publisher Albert Skira.[33] But he was still unable to finish *The Yellow Dress,* and that October he told Tériade about his struggle with it:

> In my Nice studio, before my departure for Tahiti, I had worked several months on a painting without finishing it. During my trip, even while strongly impressed by what I was seeing every day, I often thought of the work I had left unfinished. I might even say that I thought of it constantly. Returning to Nice for a month this summer, I went back to the painting and worked on it every day. Then I left again for America. And during the crossing I realized what I had to do—that is, the weakness in the construction of my painting and its possible resolution. I am anxious to go back to it today.[34]

But even after this third period of work on the painting, Matisse was dissatisfied, and it remained unfinished until after he returned from yet another trip to the United States, in January 1931.

As can be seen in the pentimenti, Matisse enlarged the figure in *The Yellow Dress* as the painting progressed, while the background remained basically unchanged. The repainting of the woman invested her with a sense of monumental scale that utterly transformed the nominal subject: an elaborately dressed young woman seated in an incongruously sedate way in front of an open window. As the painting developed, Matisse also expanded and simplified her dress, so that we

33 Early in 1930 Matisse agreed to do an illustrated book for Albert Skira, La Fontaine's *Amours de Psyche*. But later that spring, he decided instead to illustrate a selection of Mallarmé's poetry, which was published in 1932 as *Poésies de Stéphane Mallarmé.*

34 Quoted in "Entretien avec Tériade," *L'Intransigeant,* October 20 and 27, 1930; translated in *Matisse on Art,* p. 88. According to Matisse's pocket diary, he was interviewed by Tériade on October 15, 17, and 22. Matisse Archives, Paris. For details on the circumstances of Matisse's travels, see Jack Flam, *Matisse: The Dance* (Washington, D.C.: National Gallery of Art, 1993).

PLATE 37
Tiari (with Necklace). (1930). Bronze, with gold chain; cast 1/10. 8 x 5 5/8 x 7 5/8 in. (20.3 x 14.3 x 19.4 cm). BMA 1950.438

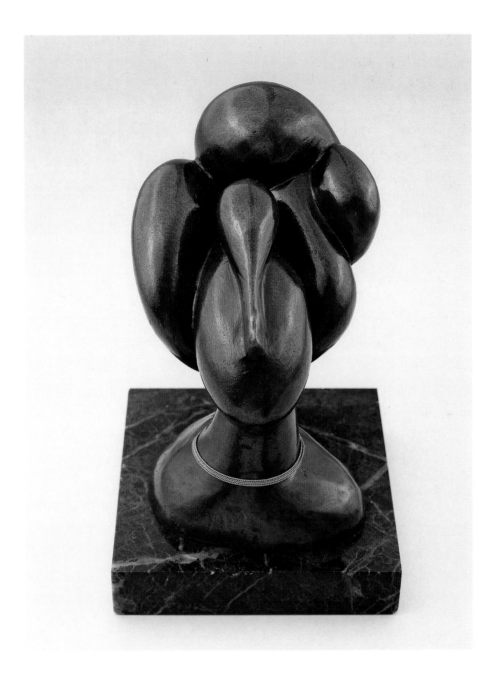

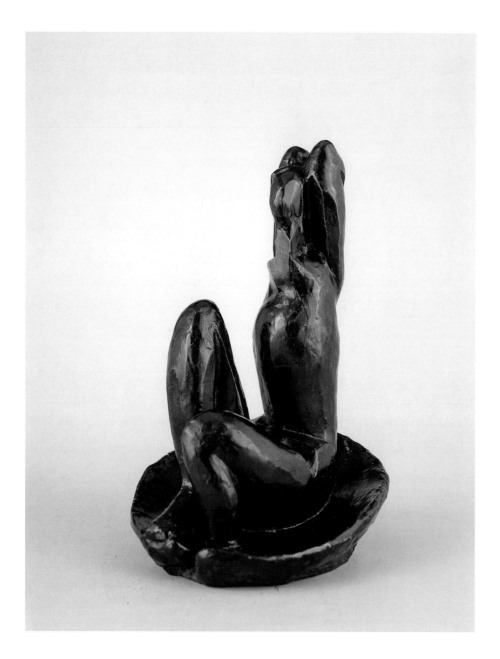

read it as a large, burgeoning form from which the upper part of her body seems to emerge right before our eyes. The idea of a female form that appears to be expanding upward is similar to that in the sculptures *Tiari (with Necklace)* (PL. 37) and *Venus in a Shell I* of 1930 (PL. 38). In fact, it was easier for Matisse to simplify the forms in his sculptures than in his paintings at this time, and to be more direct about their metaphorical implications. In *Venus in a Shell* the female figure is conceived as a plant growing out of a dish, lending her a powerful sense of symbolic import. A similar metaphor is apparent in *Tiari,* in which the subject is actually a tropical plant that resembles the bust of a woman. Compounding one unusual visual pun with another, Matisse even put a necklace on the cast of this sculpture in The Cone Collection—a surrealistic gesture that is unique in his art.

Tiari and *Venus in a Shell* are indicative of how crucial outline or silhouette was in Matisse's late sculptures, which have simpler and smoother surfaces than his earlier ones. A similar tendency is seen in his later paintings, in which linear definition and flatly painted, silhouette-like forms become increasingly important. In this context, *The Yellow Dress* plays a significant intermediate role, signaling a new austerity and simplification of form in his work. In the sculptures, perhaps because he was not working directly from the model, he was more easily able to achieve the kind of simplification that he wanted. In *The Yellow Dress,* he had to struggle hard to achieve the kind of balance that he sought between modeled form and outline, and between what he characterized as "that which is typical and that

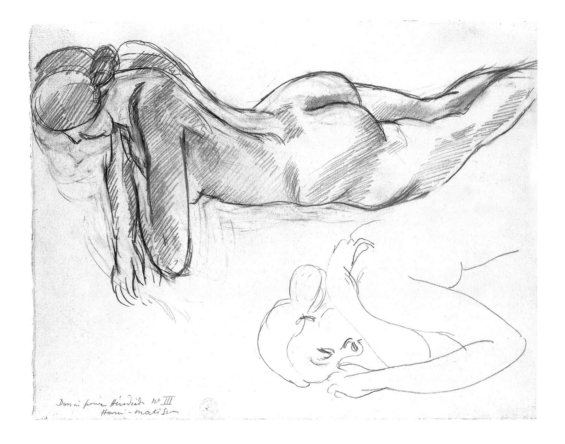

PLATE 39
Third in a sequence of four
preliminary drawings for
Hérodiade III, from *Poésies de
Stéphane Mallarmé*. (c. 1932).
Pencil. 9 7/8 x 12 7/8 in. (251 x
328 mm). BMA 1950.12.711

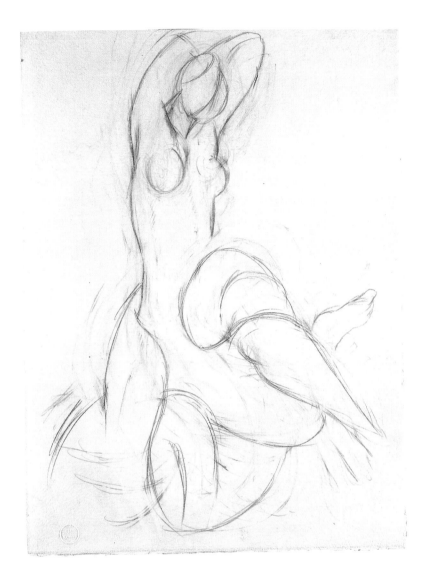

PLATE 40
Preliminary drawing for
Homage III, Page Proof Volume,
from *Poésies de Stéphane Mallarmé.*
(c. 1932). Pencil. 13 x 10 1/8 in.
(330 x 257 mm). BMA 1950.692xv

which is individual, a distillation of everything that I see and feel before a subject."[35]

Both the Barnes mural and the Mallarmé book encouraged Matisse to move away from the depiction of things in an illusionistic space, as seen from a specific point of view and in a particular light and atmosphere. Instead he became increasingly involved with the evocation of linear, signlike forms in a flattened and abstracted space. Matisse spent an enormous amount of effort on the Mallarmé book, for which he chose the typeface and designed the layout as well as the illustrations, which are rendered with the same kind of linear emphasis that he was exploring in the mural design. Even though the Mallarmé illustrations are of imaginary subjects, Matisse did extensive studies from nature for them. Figures such *Hérodiade III* (PL. 39) seem to be based on life drawings, and as late as August 1932 Matisse was still doing landscape drawings in the Loup valley that he planned to use for the Mallarmé book.[36]

Most of the numerous studies that Matisse made for the Mallarmé etchings were acquired by Etta Cone shortly after the book was published, and they constitute an extraordinarily rich document. In them we can see how Matisse refined specific images and synthesized them into elegantly concise linear designs. We can also see how similar they are to the ongoing process of linear synthesis in his paintings and sculptures of the period. Some compositions seem clearly related to his 1927–28 paintings of pairs of odalisques. Others, such as *Homage III* (PL. 40), recall the suave and streamlined silhouettes of his recent sculptures, such as *Venus in a Shell*. The Mallarmé etchings thus served as a

35 Quoted in Ragnar Hoppe, "På visit hos Matisse," 1919; reprinted in *Städer och Konstnärer, resebrev och essäer om Konst* (Stockholm, 1931); translated in *Matisse on Art*, p. 76 (translation slightly modified).

36 Letter from Matisse to his son Pierre, August 17, 1932. Pierre Matisse Archives, Pierpont Morgan Library, New York.

PLATE 41
Dr. Claribel Cone (IV/IV). (1931–34). Charcoal with stumping and erasing. 23 1/4 x 16 in. (591 x 406 mm). BMA 1950.12.71

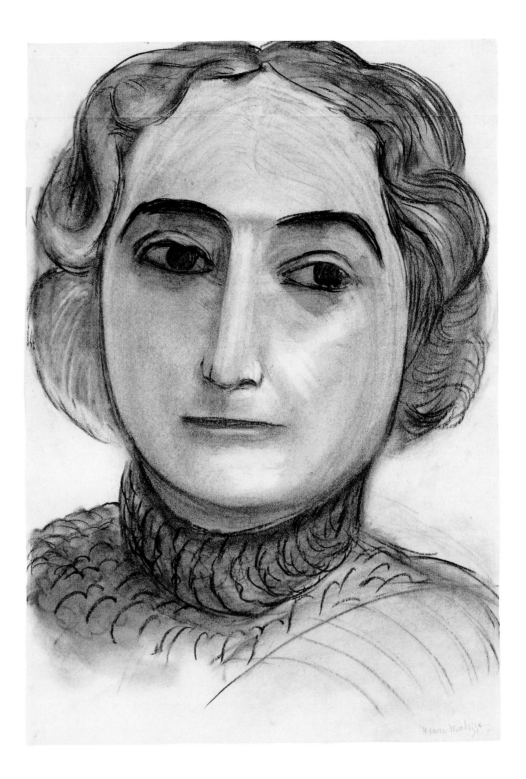

compendium of motifs and poses. His work on them provided a kind of workshop, along with the Barnes murals, in which many basic elements of his late style were forged.

When Matisse visited Etta Cone in Baltimore in December 1930, she asked him to do a portrait drawing of her sister Claribel, who had died the previous fall (PL. 41). (In a nice gesture, Matisse also gave Etta a drawing of herself, along with five studies for it.) For this project Matisse began by working from a 1909 photograph (FIG. 9a), in which Claribel is portrayed in a pensive mood, seated with her head in one hand and her other hand resting on a book. Matisse did three pencil drawings based on this photograph. But for the final charcoal drawing he seems to have worked from two very different photographs of Claribel, taken in 1915–16 (FIGS. 9b, c), in which his subject's straightforward and forceful character is emphasized. In the final drawing, Matisse no longer used the photographs as a direct model to be copied but as a generalized source of inspiration. He described the process of imitation and invention in a letter to the painter Simon Bussy: "I am still working on my portraits from photographs of my two lady collectors from Baltimore…somewhat arduous work …because imagination, memory, and the exactitude of the photograph must work together to produce the truth." Matisse then discussed the very different characters of the two sisters:

> One of them [Claribel] beautiful, possessing a noble and glorious beauty, with lovely hair in full, old-fashioned waves—satisfied and dominating. The other [Etta] with the same majesty of a Queen of Israel, but with less external beauty and straight hair, with lovely lines however that fall

FIG. 9A
Claribel Cone, 1909 (age 45). The Baltimore Museum of Art, Cone Archives

FIG. 9B
Claribel Cone, c. 1915–16 (age 51 – 52), Munich. The Baltimore Museum of Art, Cone Archives

like those in her face, and with a depth of expression that is touching—always submissive to her glorious sister but attentive to everything. Simplified means, paper and charcoal. The second portrait [of Etta] is finished, I'm working on the first, of which you've already seen the pencil studies. I've been working on them every morning for nearly a month now—it's quite hard but I'm learning a lot.[37]

As we have seen, Matisse had occasionally worked from photographs—though not for portraits—and had sometimes done paintings and drawings in pairs or small series. But previously he had avoided showing such series together. Now he became ever more interested in working in series, and also in having his works photographed while they were in progress—an indication of his increased self-consciousness about the creative process. While working on the Barnes mural, he had used the in-progress photographs to have a record of the numerous changes in the composition, and he also began to make those changes with small pieces of paper, which he would color, cut to size, and pin to the surface of the canvas. This allowed him to make revisions quickly, without having to wait for the paint to dry. The use of cut paper, which induced Matisse to work in a flatter and more abstract way, would have important repercussions in his later work, culminating in his use of paper cutouts as an independent medium.

During the 1930s Matisse developed an increasingly condensed and signlike notion of form. In a number of paintings that were photographed in various stages while he worked on them, such as *The Pink Nude* of 1935, we can

37 Letter from Matisse to Simon Bussy, May 25, 1934. Musée du Louvre, Paris.

FIG. 9C
Claribel Cone, c. 1915–16 (age 51–52), Munich. The Baltimore Museum of Art, Cone Archives

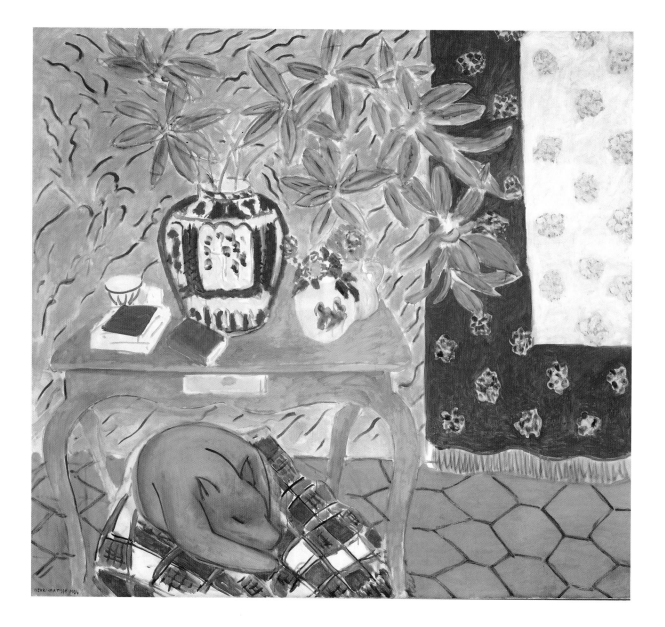

PLATE 42
Interior with Dog, formerly called
"The Magnolia Branch." 1934.
Oil on canvas. 61 x 65 3/4 in.
(155 x 167 cm). BMA 1950.257

38 In-progress photographs of a number of works from this period are reproduced in Lydia Delectorskaya, *With Apparent Ease...Henri Matisse Paintings from 1935–1939* (Paris: Adrien Maeght, 1988).

see the general way that his paintings evolved at this time.[38] He usually started with an image that was painted perceptually and in which the subject was seen from a fairly specific viewpoint and included a good deal of incidental detail. Gradually, he eliminated detail, simplified the forms, and flattened and abstracted the space so as to reduce the sense of a particular viewpoint. His pictures were transformed into ensembles of distilled pictorial signs for the things represented, and these signs began to assert an independence from the total picture space. Although things were still depicted as sharing the same physical environment, the picture space in such paintings is less tangible than in Matisse's earlier works, and a new emphasis was given to flat areas of bright color and to the rhythmic patterning of the spaces between the main objects represented.

Although several elements of Matisse's late style were already present in the Barnes and Mallarmé projects, he did not make unimpeded progress. The same kinds of hesitations between direct perception and conceptualization that had surrounded his struggles with *The Yellow Dress* continued to trouble him in the early 1930s. These are especially apparent in *Interior with Dog* of 1934 (PL. 42), which is at once a fairly realistic observation of a scene from daily life and a fully orchestrated decorative composition. Just how much thought went into this apparently casual composition can be seen in a pair of drawings that Matisse did for it (PLS. 43, 44), in which he experimented with different views of the motif and varying degrees of decorative patterning and detail. In one of the drawings, he not only renders more of the dog but also depicts the tiles on the floor and even a radiator that was in the room,

PLATE 43
Study for Interior with Dog.
(1934). Graphite. 9 3/8 x 12 1/2 in.
(239 x 319 mm). BMA 1950.12.42

PLATE 44
Study for Interior with Dog. (1934).
Graphite. 9 3/8 x 12 1/2 in. (239 x
319 mm). The Baltimore Museum
of Art: Gift of Mr. and Mrs. Pierre
Matisse, in Memory of Dr.
Claribel Cone and Miss Etta Cone.
BMA 1971.8

but which he edited out of the painted composition. Only when we look at the different views of the room in the drawings and the painting can we reconstruct what the room actually looked like. Although based on a real place, *Interior with Dog* is an imaginative reinvention of it.

The painting is full of complexly orchestrated areas of different patterns, which interrelate in fascinating ways. Some are fairly obvious, such as the way the wallpaper interacts with the magnolia branches, or the way the flowers in the small vases echo the floral patterns in the hanging cloths. Others, such as the rhyme between the rectangular pattern on the blanket under the dog and the books on the table, are more subtle and provocative: the way our attention moves from the oversize dog up to the books suggests a contrast between animal instincts and civilization. Especially striking is the size of the painting, which envelops the viewer, calling to mind the mural compositions Matisse had recently been working on and also anticipating the monumental, decorative ambitions that would dominate his work during the next two decades.

Another transitional painting is *Blue Eyes* of 1935 (PL. 45), a vivid portrait of Lydia Delectorskaya, who began to model for Matisse in 1934 and who was his muse and companion for the rest of his life.[39] In this painting, the technique is especially rich and varied. At times the rendering is quite optical, almost impressionistic, as in the scumbled green velvet of the chair. Yet the drawing is synthetic and abstracted, especially in the way the woman's left shoulder is raised and flattened and in the way her arms wrap back around her head, lending the painting an air of profound intimacy and introspection.

39 The title is a curious one. Although Lydia Delectorskaya's eyes were vivid blue, the eyes of the woman in the painting are a cool bluish brown. Yet because of the way her eye color is played against the creamy skin tones and the blue stripes of the blouse, they give the impression of being vividly blue despite the virtual absence of blue paint.

PLATE 45
Blue Eyes. 1935. Oil on canvas.
15 x 18 in. (38.1 x 45.7 cm).
BMA 1950.259

The bold rendering of the striped blouse sets up an interesting contrast between the materiality of the external world and the subjective inner world that we sense in the woman's dreamy gaze.[40]

One of Matisse's most compelling pictures of this period is *The Pink Nude* (PL. 46), an important work in the transition both to his late painting style and to his cutouts. It is one of the first easel paintings in which Matisse used cut paper to modify the composition; evidence can still be seen in the little pinpricks on the surface of the canvas. It is also one of the first easel pictures that Matisse had photographed while he was working on it; he encouraged the almost immediate publication of the photographs.[41] He also proudly sent a set of the photographs to Etta Cone, who had been closely following his recent work and who could not resist acquiring the painting shortly after it was finished.

Matisse worked on *The Pink Nude* for several months, beginning on May 3 and finishing on October 30, 1935. As can be seen in the in-progress photographs, the painting started as a relatively naturalistic rendering of a woman reclining on a chaise longue, with a chair and a vase of flowers beside her (FIG. 10; State I). As the picture developed, Matisse radically altered not only the composition but the whole structure—and indeed its whole pictorial language. He progressively flattened the image and strove for a balance between the organic curves of the figure and the regular, geometric patterning in the background (States V–VIII). At first, this was articulated by the use of a striped background pattern harshly set against the soft curves of the woman's body (State IX). This was succeeded by an irregular gridlike pattern, established with strips of cut

40 Matisse addressed a similar theme in *The Dream* of 1935 (Musée National d'Art Moderne, Paris), in which we view the woman from up close and feel that we have an intimate—almost voyeuristic—relationship to her.

41 Eight of the twenty-one photographs of *The Pink Nude* in progress, enough to give a clear idea of Matisse's method, were published shortly after the painting was finished, in the revised edition of Roger Fry's book, *Henri Matisse* (London and New York, 1935), pl. 57.

paper (State X). Still unsatisfied, Matisse began to make the woman herself more rectilinear (State XII), and then began to flatten and abstract her form extremely before he arrived at the final image (States XIII–XXI). In the finished painting, her body is conceived as a series of slowly moving, sinuous arabesques played against the grid pattern behind her—like a vine growing across a trellis. This contrast between the arabesques and the grid suggests a number of conceptual polarities, as between dynamism and stasis, passion and reason, energy and measure, nature and culture. The process of formal refinement in this painting is also one of increasingly clear conceptualization.

The transformation of the figure and its surrounding space was accompanied by a transformation of the other objects in the painting, which eventually came to function as displaced attributes of the woman. In the finished painting, the ceramic vase (which previously had been painted red) has been painted pink, the same color as the woman's skin—as if to suggest a correspondence between the generative qualities of her flesh and the flowers that grow from the earthen vase. The flowers are also transformed, translated into a curving flat yellow form—a condensed sign for the energy of their growth. The chair, which in the earlier versions was clearly a piece of furniture, has now become an abstract inverted double spiral—recalling an ancient symbol of procreation and fertility. The signs for vase, flowers, and fertility are thus set emblematically above the undulating curves of the woman's body, suggesting a symbolic interchange of attributes.

The pose of the woman in *The Pink Nude* is a variation on that in *Blue Nude* of 1907, which combined the pose of the

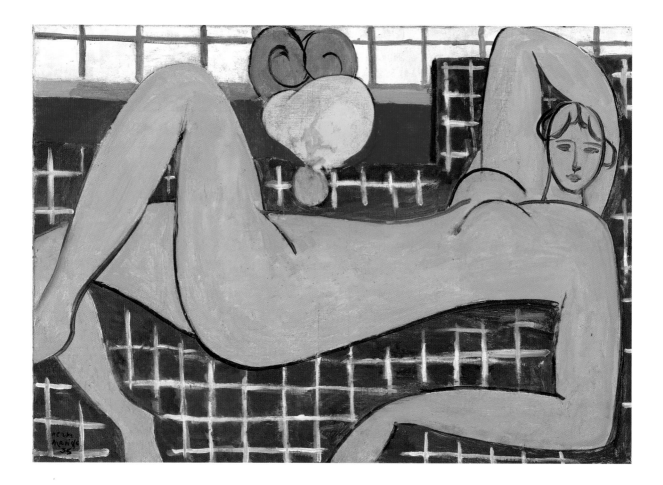

PLATE 46
Large Reclining Nude (also known
as *The Pink Nude*). 1935. Oil
on canvas. 26 x 36 1/2 in. (66 x
92.7 cm). BMA 1950.258

reclining nude in Ingres's *Odalisque with Slave* with a Cézannesque rendering. In *The Pink Nude* the reference to Ingres is even stronger. Not only does Matisse now orient the figure in the same direction that Ingres had, but the rendering also has an Ingres-like coolness. Matisse had painted *Blue Nude* as an evocation of the lush fertility of a desert oasis, as a kind of modern Venus suggesting the procreative energy of the spring earth. *The Pink Nude* seems to share a similar underlying theme, but its subject is transformed by the very different formal embodiment. The figure in *Blue Nude* is vigorously painted and sculpturally modeled, the woman earthy, rough, and sensual, and the picture as a whole evoked a world conceived in terms of dynamism and flux. *The Pink Nude,* by contrast, is painted in a more restrained and lyrical way. The woman is more elegant and more ethereal, and evokes a cooler sort of sensuality. It is a more obviously intellectualized image, in which the woman becomes an abstract sign of sensuality within a disembodied space. (Matisse, nonetheless, worked hard to keep *The Pink Nude* from becoming too schematic: the figure is kept vibrant by irregularities in the paint application and by the way the white lines of the cloth do not quite meet her body, thus allowing her to float free of the surrounding grid.)

The Pink Nude is an important point of reference in Matisse's progression toward a new symbolic language during the 1930s, what he had described to Verdet as an adventure, "in the course of which the rhythmic syntax of the picture will be completely changed by the inversion of the relations between forms, figures, and background."[42] This change involved the creation of an increasingly linear and graphic

42 Quoted in Verdet, *Entretiens*, p. 126.

I. May 3, 1935

II. May 10, 1935

III. May 16, 1935

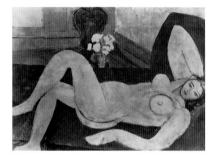

IV. May 19, 1935

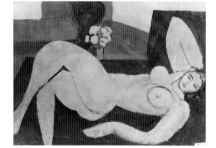

V. May 20, 1935

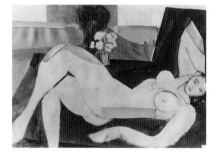

VI. May 23, 1935

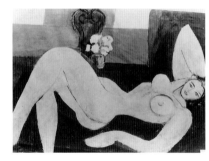

VII. May 25, 1935

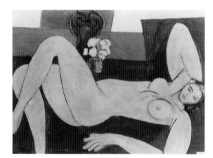

VIII. May 28, 1935

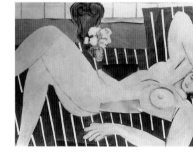

IX. May 29, 1935

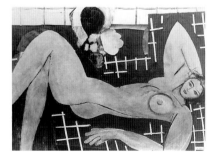

X. June 4, 1935

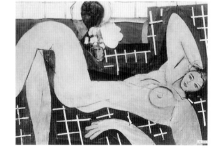

XI. June 20, 1935

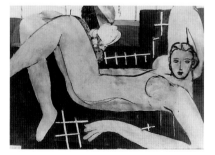

XII. August 20, 1935

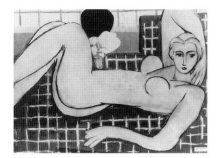

XIII. September 4, 1935

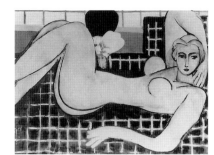

XIV. September 6, 1935

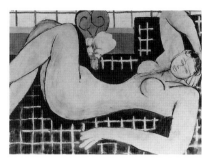

XV. September 7, 1935

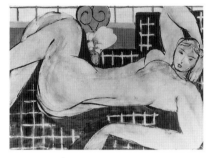

XVI. September 11, 1935

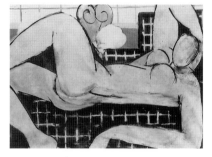

XVII. September 14, 1935

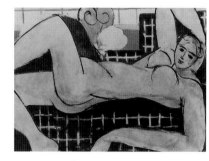

XVIII. September 15, 1935

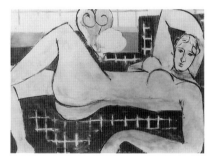

XIX. September 17, 1935

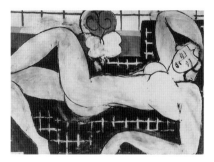

XX. October 12, 1935

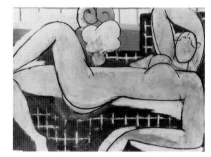

XXI. October 16, 1935

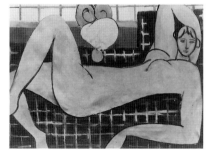

XXII. October 30, 1935 (definitive)

FIGURE 10
Large Reclining Nude (also known
as *The Pink Nude*). 1935.
Twenty-two states; photographs
sent by the artist to Etta Cone,
in letters of September 19
and November 16, 1935, The
Baltimore Museum of Art,
Cone Archives

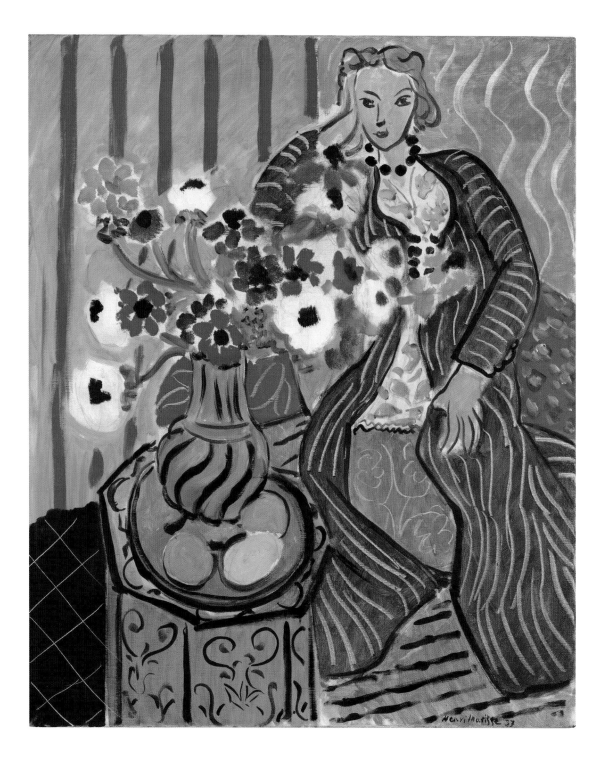

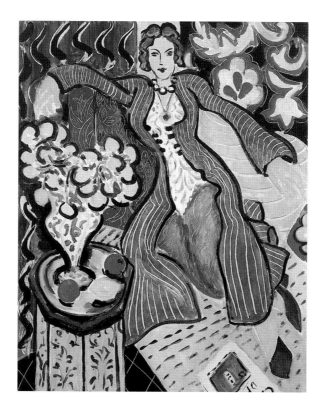

FIG. 11
Henri Matisse. *Woman in a Purple Coat.* 1937. Oil on canvas. 31 7/8 x 25 11/16 in. (80.9 x 65.2 cm). The Museum of Fine Arts, Houston; Gift of Audrey Jones Beck

PLATE 47
Purple Robe and Anemones. 1937. Oil on canvas. 28 3/4 x 23 3/4 in. (73.1 x 60.3 cm). BMA 1950.261

expressive language, in which brightly colored areas with intensively different kinds of patterning were often played against each other. The space in Matisse's paintings of the late 1930s became flatter and less tangible than in his previous work. The rectangle of the canvas was conceived less as a windowlike view or a relief space and more like a surface onto which networks of rhythmic signs can be inscribed.

In *Purple Robe and Anemones* of 1937 (PL. 47), for example, the forms of the woman and the flowers interact strongly with each other and relate directly to the various patterned areas behind them. The stripes on the woman's purple robe echo the wavy lines on the wall behind her, which in turn relate to

the sweeping curves of the front of the robe. The flowers in the vase share the same space and the same colors as her clothing, implying an exchange of energy that is further intensified by the way the incised floral forms on her skirt are echoed in the couch and table. Everything in the painting is in some sense aware of everything else, including the inanimate objects, which seem to radiate a energy that borders on consciousness. Even the pewter jug on the table, with its swirling body and up-thrusting top, articulates the themes of growth, becoming, and vitality that are expressed in the woman and flowers and inform the painting as a whole. Matisse was especially taken by the combination of elements in this painting, and he did a number of versions of the motif (FIG. 11), which are like variations on a musical theme.

A similarly fine balance between the specific and the abstract is apparent in a number of Matisse's drawings from this period, in which decorative and floral motifs play an important role. In a drawing of a model wearing an embroidered blouse, *Rumanian Blouse* of 1936 (PL. 48), the musically complex floral forms on the blouse transform the woman's body into a lush landscape. *Rumanian Blouse* is also one of a number of works done about this time that display Matisse's increasing interest in depicting the process of creation. Pinned to the drawing board in the lower left corner is a representation of the drawing we are looking at, seen in the course of its making. In *Artist and Model Reflected in a Mirror* of 1937 (PL. 49), the artist looks out at us as he draws the woman and her reflection in the mirror. Drawings such as these are informed by a remarkable dynamism and an intense "allover" effect which tend to intensify their abstractness.[43]

43 A number of drawings that refer to the process of creation were reproduced in *Dessins de Henri-Matisse*, 1936, a special number of *Cahiers d'Art*.

PLATE 48
Rumanian Blouse. 1936.
Pen and ink. 20 x 15 in. (508 x
81 mm). BMA 1950.12.48

PLATE 49
*Artist and Model Reflected in a
Mirror.* 1937. Pen and ink.
24 1/8 x 16 in. (612 x 407 mm).
BMA 1950.12.51

The ways in which Matisse balanced observation and abstraction varied quite a bit during this period. Sometimes, as in *Striped Robe, Fruit, and Anemones,* 1940 (PL. 50), the picture space is delicately poised between describing an actual space and being a virtually abstract ensemble of forms and colors. In this picture, the brushstrokes that delineate the woman and her surroundings function so independently of what they describe that they force us to recognize an abstracted space that is coterminous with the more literal one that is represented. This combination of the real and the abstracted allows for an even freer exchange of energy between animate and inanimate entities than in Matisse's previous paintings and implies a radical disembodiment similar to that in his cutouts.

In 1943 Matisse moved to the hill town of Vence to escape the wartime hubbub of Nice. During the years he spent there, he continued to paint but began to work increasingly with paper cutouts as an independent medium, in part because abdominal surgery had made it difficult for him to remain standing for long periods of time. *Two Girls, Red and Green Background* (PL. 51) is one of an extended series of small but highly concentrated paintings that Matisse did there as part of his last, glorious outburst of painting. He appears to have been particularly pleased with these freely brushed and brightly colored paintings; shortly after they were done, most of them were reproduced in color in a special number of the periodical *Verve.*[44] These pictures are remarkable for the freedom of their drawing and the boldness of their color harmonies, which evoke different kinds of light and create a variety of emotional moods. In *Two Girls, Red and Green Background,* the space

44 *Verve* 6, nos. 21–22 (1948).

PLATE 50
Striped Robe, Fruit, and Anemones.
1940. Oil on canvas. 21 3/8 x
25 1/2 in. (54.3 x 64.8 cm). BMA
1950.263

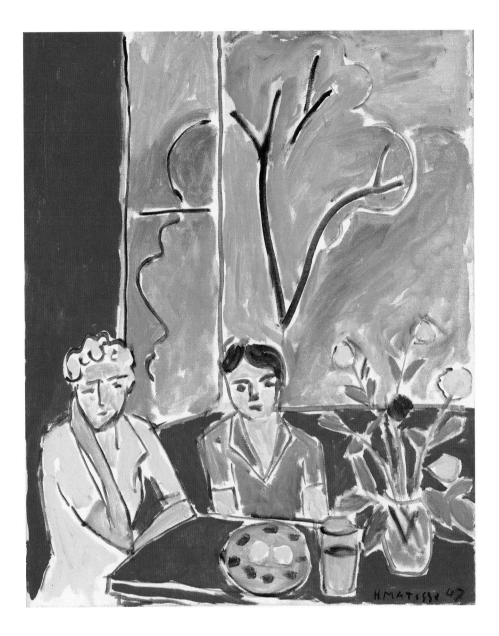

PLATE 51
*Two Girls, Red and Green
Background.* 1947. Oil on canvas.
22 1/8 x 18 1/4 in. (56.2 x
46.4 cm). BMA 1950.264

inside the room is defined by broad planes of bright red, while the outdoors is rendered in cool blues and blue-greens. The painting is full of bold chromatic gestures, such as the way the bluish outdoor colors are brought forward into the room and appear in the objects on the table and in the dress of one of the girls. Equally striking is the way vivid yellow accents are set in contrast to the dominant reds, blues, greens, and violets. An especially subtle chromatic note is sounded by the dark red flower that is bisected by the line of the window, which lends even greater energy to the brighter reds in the rest of the painting.

The mood of this painting, like that of most of the others in the series, is celebratory. There is a vivacious exchange of energy between the different orders of beings and things—between the two girls and everything that surrounds them—the trees, the flowers, and the objects on the table. Everything seems to share a common source of vitality, which is transmitted in part by our awareness of the electric movement of the artist's brush. As in other paintings in this series, the overall space is ethereal and the various entities within it are abbreviated into signlike forms that are the painterly equivalent of the disembodied, abstract space of Matisse's late cutouts. The drawing in the landscape is especially expansive. The undulating curves and the abstract dynamism of the tree shape reflected on the window pane seem to be especially indebted to the fluid movement that the artist's hand had acquired while cutting into paper with a pair of scissors.

This is not surprising, for it was at Vence that Matisse also did the cut-paper compositions for his illustrated book *Jazz,* which was published in 1947 as a folio of twenty color plates accompanied by a rambling text composed by Matisse and reproduced in

his own large handwriting. In *Jazz*, as in the subsequent cutouts, the forms were conceived right from the beginning as abstract signs set within a discontinuous space and structured in terms of surface effect rather than the illusion of a view into a window-like space.

In the cutouts, several aspects of the late paintings are taken even closer to the edge of abstraction. The *Jazz* images have a striking disjunctiveness and convey a remarkable spontaneity, which is built right into the technique, in which forms were cut out of colored paper and put down whole onto the picture, provisionally set in the composition with a pin or a bit of paste. Sometimes the placement of the form worked, sometimes it did not. If it did not, Matisse could simply lift it and put it some-where else, or save it for another composition. Moreover, every time a shape was cut in paper, another shape, the negative image of the first, was also created. Matisse was thus able to create something like a repertoire of forms, which could be rearranged, interchanged, and even stored away for future use.

The visual conceits created by this poetic use of form were part of an improvisational aesthetic that had its own kind of technical virtuosity. For example, the two torsos in *Formes* (PL. 52) are negative and (slightly modified) positive shapes cut from the same piece of blue. And several of the plant forms in the three *Lagoon* compositions are made by combining various positive and negative shapes that were cut from the same pieces of paper (PLS. 53, 54).

The "sign" aspect of the individual forms cut for *Jazz* extends to the total images, which are removed from the spatial and temporal constraints of the natural world. Unlike the imagery of Matisse's earlier works, the cutouts do not imply the specific

physical position of the viewer in relation to the space of the image. Their imagery occurs, like that of poetry, in the mind.

The new pictorial vocabulary of Matisse's cutouts, which clearly took its point of departure from the increasingly abstract forms of his late paintings, allowed Matisse to revitalize his art during the last decade of his life, when physical infirmity limited his ability to paint. With his new cutout technique, he was able to treat a number of new themes and give fresh form to some old ambitions by intensifying the decorative concerns that had been so important to him throughout his career. Drawing on rhythmic and floral elements that had already been present in such paintings as *Small Rumanian Blouse With Foliage* and *Purple Robe and Anemones* of 1937, Matisse was able to apply his new formal vocabulary to a wide range of decorative compositions and create a new kind of pictorial space.

The possibility of creating a new kind of space that would transcend the everyday seems to have haunted Matisse throughout his career. In 1908, when he first formulated his thoughts about painting, he had written about probing beyond "the superficial existence of beings and things" and seeking "a truer, more essential character" that would "give to reality a more lasting interpretation."[45] In 1942, as he first became involved with the abstracted space of the cutouts, he wrote that he was aware that "above me, above any motif, above the studio, even above the house there was a cosmic space in which I was as unconscious of any walls as a fish in the sea."[46] The cutout technique allowed him to realize more fully than before this intuition of a "cosmic space." The condensed, sign-like, and placeless imagery of the cutouts can be seen as the ultimate step in Matisse's lifelong process of seeking new ways to represent abiding truths.

45 Matisse, "Notes d'un peintre"; translated in *Matisse on Art*, p. 39.

46 Quoted in Louis Aragon, *Henri Matisse, Roman* (Paris: Flammarion, 1972), vol. 1, p. 208.

PLATE 52
Jazz: Formes. 1947. Hand-applied
stencil. Cover: 17 1/8 x 13 1/4 in.
(435 x 336 mm). Cover sheet:
16 3/4 x 12 7/8 in. (425 x
328 mm). BMA 1950.12.745

PLATES 53–54
Jazz: Lagoon. 1947. Hand-applied
stencil. Cover: 17 1/8 x 13 1/4 in.
(435 x 336 mm). Cover sheet:
16 3/4 x 12 7/8 in. (425 x
328 mm). BMA 1950.12.745

Suggested Reading on Henri Matisse and The Cone Collection

Barr, Alfred H., Jr. *Matisse: His Art and His Public*. New York: The Museum of Modern Art, 1951.

Bois, Yve-Alain. *Matisse and Picasso*. Paris: Flammarion; Fort Worth: Kimbell Art Museum, 1998.

Carlson, Victor. *Matisse as a Draughtsman*. Baltimore: The Baltimore Museum of Art, 1971.

Centre Georges Pompidou. *Henri Matisse, 1904–1917*. Paris: Centre Georges Pompidou, 1993.

Cowart, Jack, Jack Flam, Dominique Fourcade, and John H. Neff. *Henri Matisse, Paper Cut-Outs*. St. Louis: St. Louis Art Museum; Detroit: The Detroit Institute of Arts, 1977.

Cowart, Jack, and Dominique Fourcade. *Henri Matisse: The Early Years in Nice, 1916–1930*. Washington, D.C.: National Gallery of Art; New York: Harry N. Abrams, 1986.

Cowart, Jack, et al. *Matisse in Morocco: The Paintings and Drawings, 1912–1913*. Washington, D.C.: National Gallery of Art, 1990.

Delectorskaya, Lydia. *With Apparent Ease…: Henri Matisse Paintings from 1935–1939*. Paris: Adrien Maeght, 1988.

Duthuit, Claude, and Wanda de Guébriant. *Henri Matisse: Catalogue raisonné de l'oeuvre sculpté*. Paris: C. Duthuit, 1997.

Duthuit, Claude, and Françoise Garnaud. *Henri Matisse: Catalogue raisonné des ouvrages illustrés*. Paris: Claude Duthuit, 1988.

Duthuit-Matisse, Marguerite, and Claude Duthuit, eds. *Henri Matisse: Catalogue raisonné de l'oeuvre gravé*. 2 vols. Paris: C. Duthuit, 1983.

Elderfield, John. *The Drawings of Henri Matisse*. London: Arts Council of Great Britain and Thames and Hudson, 1984.

———. *Henri Matisse: A Retrospective*. New York: The Museum of Modern Art, 1992; distributed by Harry N. Abrams.

———. *Pleasuring Painting: Matisse's Feminine Representations*. New York: Thames and Hudson, 1995.

Elsen, Albert E. *The Sculpture of Henri Matisse*. New York: Harry N. Abrams, 1972.

Flam, Jack. *Matisse: The Man and His Art, 1869–1918*. Ithaca and London: Cornell University Press, 1986.

———. *Matisse: A Retrospective*. New York: H. L. Levin Associates, 1988; distributed by Macmillan.

———. *Matisse: The Dance*. Washington, D.C.: National Gallery of Art, 1993.

———. *Matisse: Image into Sign*. St. Louis: The Saint Louis Museum of Art, 1993.

———. *Matisse on Art*. Berkeley and Los Angeles: University of California Press, 1995.

Gilot, Françoise. *Matisse and Picasso: A Friendship in Art*. New York: Doubleday, Anchor Books, 1992.

Gowing, Lawrence. *Matisse*. New York and Toronto: Oxford University Press, 1979.

Hahnloser, Margrit. *Matisse: The Graphic Work*. New York: Rizzoli, 1988.

Hirschland, Ellen B. "The Cone Sisters and the Stein Family." In *Four Americans in Paris: The Collections of Gertrude Stein and her Family*. New York: The Museum of Modern Art, 1970.

Monod-Fontaine, Isabelle, et al. *Matisse: Oeuvres de Henri Matisse*. Paris: Musée National d'Art Moderne, Centre Georges Pompidou, 1989.

Musée National d'Arte Moderne. *Henri Matisse: Dessins et sculpture*. Paris: Centre National d'Art et de Culture Georges Pompidou, 1975.

O'Brian, John. *Ruthless Hedonism: The American Reception of Matisse*. Chicago and London: University of Chicago Press, 1999.

Pollack, Barbara. *The Collectors: Dr. Claribel and Miss Etta Cone*. Indianapolis and New York: Bobbs Merrill, 1962.

Richardson, Brenda. *Dr. Claribel & Miss Etta: The Cone Collection of The Baltimore Museum of Art*. Baltimore: The Baltimore Museum of Art, 1992.

Russell, John. *Matisse: Father and Son*. New York: Harry N. Abrams, 1999.

Schneider, Pierre. *Matisse*. New York: Rizzoli, 1984.

Spurling, Hilary. *The Unknown Matisse*. New York: Alfred A. Knopf, 1998.

Wineapple, Brenda. *Sister Brother: Gertrude and Leo Stein*. Baltimore: The Johns Hopkins University Press, 1996.